IMAGES
of America
MEDINA

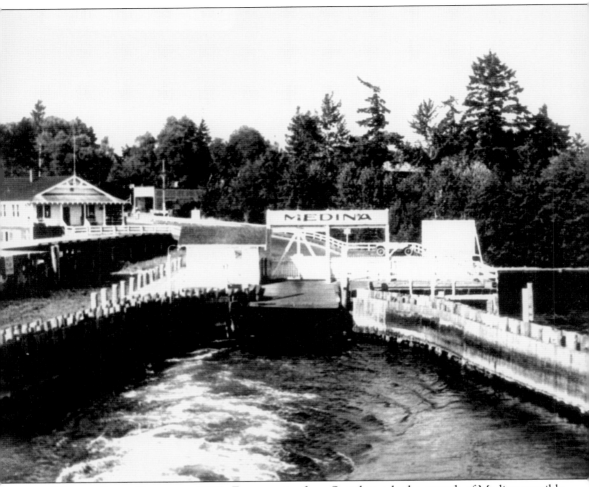

MEDINA FERRY TERMINAL, 1928. Ferry service from Seattle made the growth of Medina possible and shaped the community from the beginning. (Courtesy of the Eastside Heritage Center.)

ON THE COVER: Jack Park, to the left of the wagon, celebrates his eighth birthday with friends in Medina on July 22, 1922. They are seated in front of the Park family's first home in Medina. The home was later owned by longtime Medina resident Jack Reynolds. (Courtesy of Elizabeth Park Luis.)

IMAGES
of America

MEDINA

Michael Luis

ARCADIA
PUBLISHING

Published by Arcadia Publishing
Charleston, South Carolina

Printed in the United States of America

Library of Congress Control Number: 2010935857

For all general information, please contact Arcadia Publishing:
Telephone 843-853-2070
Fax 843-853-0044
E-mail sales@arcadiapublishing.com
For customer service and orders:
Toll-Free 1-888-313-2665

Visit us on the Internet at www.arcadiapublishing.com

DEDICATION. To William E. Park, Medina pioneer, leader, and community builder. (Courtesy of Elizabeth Park Luis.)

CONTENTS

ACKNOWLEDGMENTS

This project began with documents and photographs from a family collection and grew to a more complete portrait of Medina with the help of many people.

The staff and volunteers at the Eastside Heritage Center—Heather Trescases, Megan Carlisle, Nancy Sheets, and Diana Ford—scouted out pictures and information from EHC's excellent collection of Eastside photographs and research materials. Rachel Baker and her colleagues at the City of Medina provided access to materials at city hall. Marcus King of the Overlake Golf and Country Club and Laura Gregg of St. Thomas Episcopal Church were very helpful in providing images and valuable research materials. Karl House at the Puget Sound Maritime Historical Society guided me to images and materials on the ferries of Lake Washington.

The majority of images in the book came from archives managed by a group of very helpful professionals. Thanks go to archivists at the Washington State Archives in Olympia and Bellevue, at the King County Archives, the map vault in the King County Roads Division, the City of Seattle, and the Seattle Public Library.

A number of current and former Medina residents provided images and memories, including Kathleen Harris Johnson, Colin Radford, Joan Anderson Shaver, and John Dillow. Many important details came from histories of St. Thomas Episcopal Church and the Overlake Golf and Country Club that were written by Patricia LaTourette Lucas, as well as Junius Rochester's book *Lakelure*. John Frost's extensive oral history for the Bellevue Historical Society was a joy to read and gives a real flavor of Medina. And I am grateful for the advice and encouragement of that sage of the Eastside, Neil McReynolds.

Many photographs and documents came from the extensive collection of my mother, Elizabeth Park Luis, whose father, William Park, served in most volunteer posts in Medina and as its first mayor.

Finally, I would like to thank my family for their patience and encouragement.

INTRODUCTION

"Seattle's Nearest and Most Beautiful Suburb." This tag appeared above Medina's column of weekly gossip in the *Lake Washington Reflector* in 1928. The publisher, W. E. LeHuquet, was never shy about boosting the Eastside, but on this point he perhaps did not exaggerate. Medina has always been a gateway to the Eastside, first as a ferry stop and later as the touchdown point for a major bridge, and it retains a lovely natural and built environment.

The story of Medina is one of gradual, graceful growth. For the first half of its life, Medina was a rural community of small farmers and orchardists with a growing number of adventurous commuters and businessmen in their waterfront estates. By the middle of the 20th century, Medina got caught up in the great suburban housing boom, but because it was already heavily settled there was little room for vast subdivisions. Instead the open spaces filled up at a more manageable pace.

Medina has maintained a distinct identity throughout its history. It had its name from the earliest days and the geography of the Three Points area provided a natural set of boundaries that defined the community and made a logical border when it came time for incorporation. With iconic buildings remaining and a school with a 100-year history, Medina has the tools to retain its sense of place.

In the mid-1800s, when Seattle itself was still sparsely populated, adventurous souls began to explore Lake Washington, hiking over the ridges to the east of town or paddling up the Black River from the south. One by one, settlers staked out claims on the eastern shore, and by 1890 Isaac Bechtel and his sons had logged off most of Medina. Berry farms and orchards sprang up throughout the newly cleared area, serving the rapidly growing population of Seattle.

Medina's first permanent settler is thought to have been Thomas Dabney, a businessman from Seattle who, in 1886, claimed the land along the shore from what is now the foot of Eighth Street around the end of Dabney Point to the south. He established the first ferry dock, Dabney's Landing, at the foot of Eighth Street and in 1890 successfully petitioned the county for a road connecting that dock with the uplands. Fifteen other landowners joined that road petition, showing that by 1890 Medina was no longer the wilderness.

That same year, Samuel Belote, who became a prominent community leader, settled in Medina with his wife, Flora. She is given credit for the name Medina. After naming the ferry landing after himself, Thomas Dabney tried to name the community "Flordeline." The ladies of the community—all three of them—thought they could do better. Flora Belote, Ruby Burke, and Eliza Geicker each suggested a name. The committee decided on Medina, the name of the holy city of Islam, which was Flora's contribution.

The first steamer to provide regular passenger service on Lake Washington was the side-wheeler *Kirkland*, which began operating in 1889. Other vessels, such as the *C. C. Calkins*, the *Vixen*, the *Winnefred*, and the *Elfin* plied their trade on the lake with a combination of fixed routes and "flag stops." Because the steamers were all privately owned and competed fiercely, an additional

passenger, spotted waving a flag from their dock, was always welcome. In addition to Dabney's Landing, passengers could catch a ferry at Clyde (now Clyde Beach), Eastland, at the foot of Eighty-fourth Avenue, and at the head of Fairweather Bay. Ferry docks were later built on both sides of Evergreen Point, one at the site of the current Lake Lane dock and another, dubbed Rom-No-More on the west side of the point.

By the turn of the century, Medina and surrounding areas had grown enough to have a schoolhouse and a few dozen permanent residents. By 1908, there were enough households to support a store and the Medina Grocery opened on the corner where it stands today. Telephone service arrived a few years later along with construction of the telephone exchange building, which now serves as the post office. When the area had enough cars, it needed a service station, and the Vollmer family opened one on the corner of Eighty-fourth Avenue and Twelfth Street, where Medina residents have been getting gas and service ever since.

The first major change to Medina came with the arrival of car ferry service in 1913. The Port of Seattle decided to get into the ferry business on the lake and commissioned a steel-hulled ferry, the *Leschi*, that could take cars from Seattle to Meydenbauer Bay, by way of Medina. Ferry service moved from Dabney's Landing down the shore to a new dock next to the current city hall. This required a new road and the constant headache of maintaining a boardwalk to allow passengers to walk up the hill out of the mud.

By 1919, a private operator, Capt. John Anderson, had taken over the *Leschi*. He began to notice that cars from Bellevue were bypassing the Meydenbauer dock and driving to Medina to shave a few minutes off their commute. Much to the consternation of Bellevue residents, Anderson stopped running to Meydenbauer entirely, making Medina the main terminal for the central Eastside.

The ferries not only brought Medina residents to and from Seattle, they also allowed Seattleites to take excursions to the Eastside. The early lake steamers often made more money taking groups on moonlight cruises than they did ferrying passengers, and visitors from the big city continued to come to Medina for picnics, rounds of golf at Overlake Golf and Country Club, or just a stroll in the country.

The second major change for Medina came when the Lake Washington Ship Canal opened and the lake was permanently lowered by nine feet. This not only left everyone's docks high and dry, it also opened new real estate along the shore. The shelf that was exposed below the formidable bluffs of central Medina provided new sites for homes and cabins. The ferry terminal, which would later become city hall, was built on this new land.

Like any pioneering community, the residents of Medina organized themselves from the beginning. Early petitions for construction of roads and ferry docks show substantial cooperation in improving the area's infrastructure. Medina was originally part of the Bellevue school district. In 1910, Medina broke off and formed its own school district that covered the area north to Twenty-fourth Street and east to Ninety-second Avenue. The new district built a schoolhouse at the corner of Eighty-fourth Avenue and Tenth Street. (Evergreen Point children went to Bay School in Hunts Point.) Medina formed its own water district in 1928.

The heart of the early Medina community was the Medina Improvement and Good Roads Club. The Articles of Incorporation of the club state its purpose as "to create community feeling among the residents of Medina, Washington and for the betterment and improvement of Medina . . . to see that the streets of Medina, Washington are provided with electric lights and sidewalks." The club paid for streetlights with regular dues and lobbied the county for better roads and sidewalks. In 1921, the club purchased a fire apparatus and parked it in a central location.

While the men were haggling about who was not paying their streetlight dues, the Ladies Auxiliary of the Medina Improvement and Good Roads Club was busy raising money and keeping the social life of Medina lively. A continual stream of card parties, dances, and dinners—open to all residents of the area—provided entertainment in an otherwise isolated area and raised money for community and school projects.

The first formal meeting minutes of the Medina Improvement and Good Roads Club, from 1915, list about 70 members. The 1920 school census for the Medina district includes roughly 50

families with children south of Twenty-fourth Street. Allowing for nonparticipants in both, it seems that by the late 1910s Medina had perhaps 100 households. By the mid-1920s the number of students had outgrown the original schoolhouse, which had been expanded, and the district constructed a new brick school building on the site of the current Medina Elementary School. By this time, it was clear that most homes did not have enough land to support farming at any scale. Medina had largely become a commuter suburb.

By the mid-1920s, Medina had come to the attention of the wealthy and powerful of Seattle who saw a place with enough space to build an impressive waterfront estate while still being within an easy commute of Seattle. Although a few of the great houses had been built earlier, the 1920s saw the arrival of mansions along what became known then as the "Gold Coast." Many of these properties remain intact today.

The next major change to come to Medina was the opening of the floating bridge across Mercer Island in 1940 that linked Seattle to the Eastside. The *Leschi* made its last run the day before the bridge opened, and although the *Ariel* bravely kept up ferry service to Evergreen Point, Medina found itself on the periphery of the transportation system instead of the middle. Even so, Medina saw its share of the Eastside's rapid postwar growth that the bridge made possible. New subdivisions sprung up, the St. Thomas congregation built a new church, the Overlake Golf and Country Club reopened, and the Bellevue School District drew up plans for new elementary schools. And, most ominously, the Washington State Highway Commission favored a Montlake-Evergreen Point route for a new floating bridge.

All this visible and anticipated growth led to the final major change that made Medina what it is today: incorporation.

As rural communities, the Points, Bellevue, Highland, Phantom Lake, and other mid-Eastside areas could get the services they needed from King County without having the burden of a municipal government. By the 1950s, this was an increasingly untenable position. The county exerted little control over land use patterns and could not provide much in the way of services like police, roads, or parks. And the county was certainly not going to stand up for any one community's interests when it came to the proposed new bridge.

The Points communities had declined to join Bellevue's successful incorporation movement in 1953. But with Clyde Hill incorporating the following year, Medina and the Three Points area were cut off from the rest of unincorporated county. The debate raged in the Points communities over whether to incorporate or to annex to Bellevue or Clyde Hill. The Medina Improvement and Good Roads Club favored incorporation but the *Bellevue American* newspaper editorialized against it and the municipal league urged annexation. A straw poll put out by the Medina Improvement and Good Roads Club did not favor incorporation, but the club kept going in that direction. By early 1955, there were active movements both for annexation and for incorporation.

Incorporation, it seemed, was a lot easier to accomplish than annexation, since it did not require the cooperation of another city. The club got its incorporation petition passed by the county commission and onto the ballot before the annexation supporters could even get in front of the Bellevue Planning Commission. Incorporation passed on July 26, 1955, by a vote of 225 to 126. The first city council consisted of William Park as mayor and council members Charles Dally, Frederic Templeton, James Barbee, Robert Behnke, Carey Donworth, and William Hagen.

The new city government wasted no time in doing what new cities generally do: zoning. Medina had been platted with various lot sizes over the years and, by the 1950s, still had relatively low densities. The city's first comprehensive plan and zoning ordinances put in place what are, even by suburban standards, large lot sizes of between 16,000 and 30,000 square feet. Although the first comprehensive plan envisioned a commercial area where Medina Circle is today, that idea faded and only one commercial enterprise—Well's Medina Nursery—has been added since incorporation. Medina's evolution has been resolutely true to the vision of its founders.

Since the completion of the Evergreen Point Bridge, Medina has evolved gradually, with spaces filled in, roads widened, and new parks built. But the basic bones were in place in the 1960s and

change has been incremental. The mansions are larger, and many of the modest homes of the past have been replaced by much larger ones. And the shiny new elementary school of the 1950s has been replaced yet again.

Medina's evolution hit a sort of inflection point in the 1990s when the technology boom brought new wealth to the Eastside. Its convenient location, excellent schools, and quiet charms made Medina a magnet for new families of more substantial means, and pushed house prices out of the reach of the moderate income families that had long made Medina their home.

The arrival of new families has provided a welcome energy to the community. The new school is bulging with students, the parks bustle with kids on the playgrounds and practicing soccer, and Medina Days is as lively as ever. Longtime residents run their dogs at Medina Park alongside newer arrivals. All in all, Medina has evolved about as gracefully as could be expected of a town with many attractions.

This book focuses on Medina mostly prior to 1970. Certainly a lot has happened since then, with the arrival of a new generation of captains of industry and their magnificent homes. And a new chapter is about to be written with the rebuilding of the Evergreen Point Bridge. The intent, however, is to capture the flavor of Medina as its early residents saw it and carry that story up to the time that the neighborhoods and institutions we know today took their final form. A glimpse into the past helps us appreciate those who made Medina the wonderful community it is today.

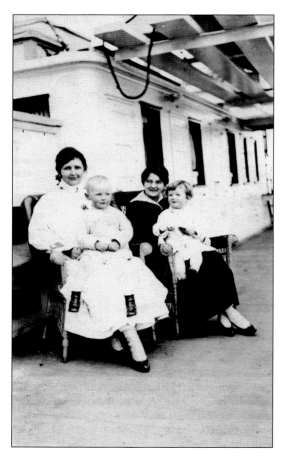

ABOARD THE LESCHI, 1917. Two mothers pose with their children aboard the ferry Leschi, which linked Seattle with Medina from 1913 until the Mercer Island Bridge opened in 1940. (Courtesy of Elizabeth Park Luis.)

One

VIEWS AND PLANS
OF MEDINA

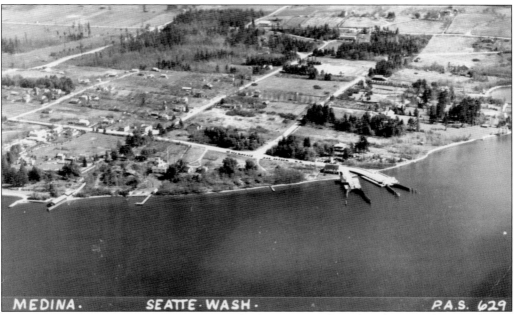

MEDINA. SEATTE·WASH· P.A.S. 629

DABNEY POINT AND THE FERRY DOCK. By the late 1920s, when this photograph was taken, a substantial number of homes had been built in Medina and much of the land had been cleared for small orchards and farms. The middle to late 1920s also saw the building boom of mansions and estates along the water, some of which can be identified here by their circular driveways. (Courtesy of the Washington State Archives.)

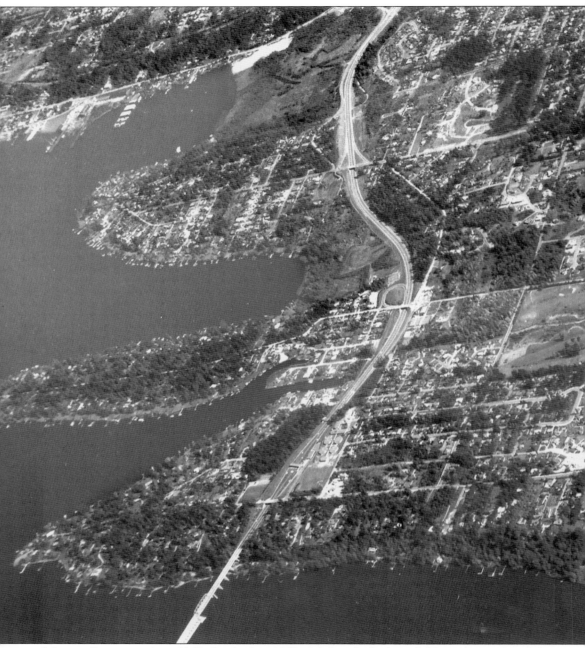

MEDINA FROM THE AIR, 1968. By the late 1960s, Medina looked much like it does today. A few areas, notably just south of Three Points School, had not filled in but the city was largely built out. The final major changes to take place were construction of Medina Park (shown here as wooded), the development of Medina Circle, which was still the Yabuki greenhouses in 1968,

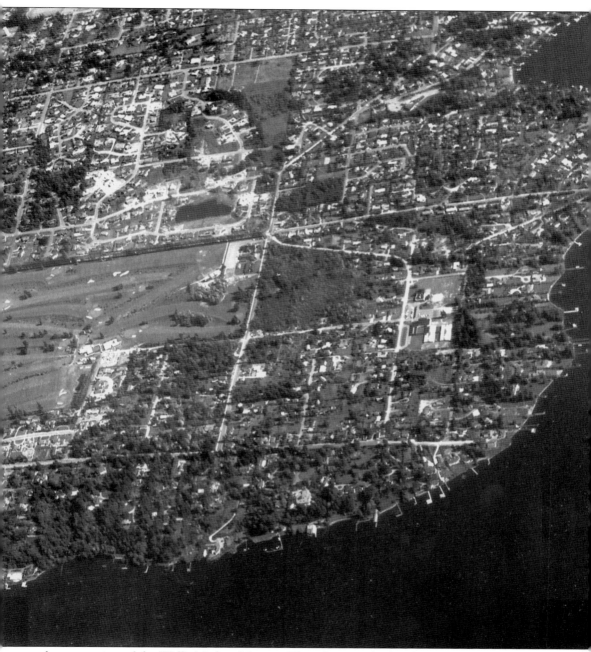

and construction of the Well's Medina Nursery. This photograph also shows how large areas of Clyde Hill remain undeveloped. Within 10 years, nearly all of these remaining areas were filled in. (Courtesy of the City of Medina.)

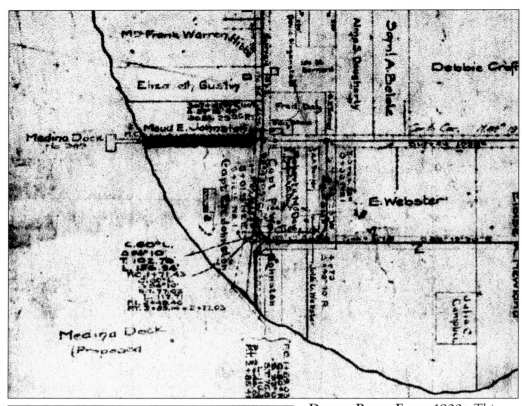

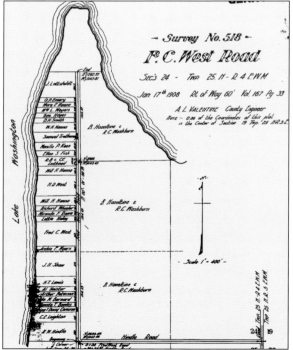

DABNEY POINT, EARLY 1900s. This map, which appears in several road history files with different markings, shows property owners in the early 1900s such as Croft, Belote, Webster, and Johnston. It also shows the location of the original ferry dock at Dabney's Landing. (Courtesy of the King County Roads Division.)

EVERGREEN POINT IN 1908. This map was created for a survey to complete Fred West Road, now the north part of Evergreen Point Road. At this early date, the waterfront properties along Lake Washington had been claimed by individual owners but the uplands and Fairweather Bay waterfront were all in the hands of two owners. (Courtesy of the King County Roads Division.)

THE BOGUE PLAN OF 1911.
In 1910, Virgil Bogue, a
planner who had worked
for the Olmstead Brothers,
drew up a master plan for
Seattle. While this plan
is best remembered for an
elaborate civic center, it also
envisioned development
around Lake Washington.
Notably it designated roads
in Medina as part of Lake
Washington Boulevard and
anticipated State Route
520 with a Yarrow Bay
Tunnel from Seattle to
Houghton. (Courtesy of the
Seattle Public Library.)

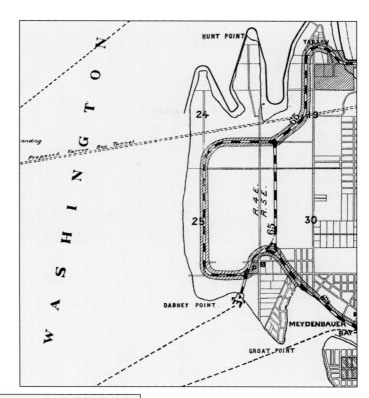

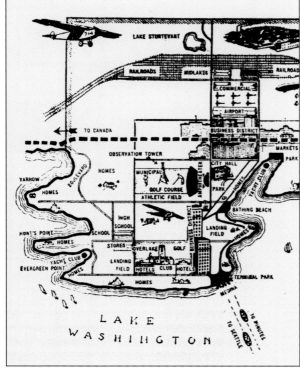

THE DITTY PLAN OF 1928. James
Ditty had even bigger ideas. His
ambitious plan, dubbed "Ditty's
Dream," drew a business district
along Twelfth Street, hotels
along Evergreen Point Road, and
a yacht club in Fairweather Bay.
The plan reflected the dreams
of aviation of the era, with two
airfields in Medina alone. Ditty,
a major landowner in Bellevue,
would see his dream for Bellevue
realized 80 years later. (Courtesy
of the Eastside Heritage Center.)

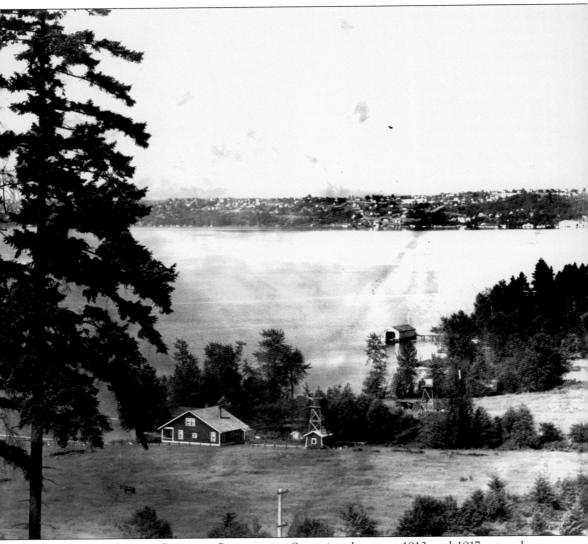

PANORAMA PART 1, LOOKING SOUTHWEST. Sometime between 1913 and 1917, an unknown photographer positioned a camera just above the old school site at what is now Eighty-fourth Avenue and Tenth Street and created an extraordinary panorama of Medina. This and the next three pages show four of the seven panels. This panel looks across the lake to Seattle's Mount Baker district. The house in the lower left appears quite near the water, and later photographs of that house, taken after Lake Washington was lowered nine feet in 1917, show that house quite far back from the beach. The lake lowering provided hundreds of acres of new land but also left the boathouse in this photograph high and dry. (Courtesy of the Washington State Archives.)

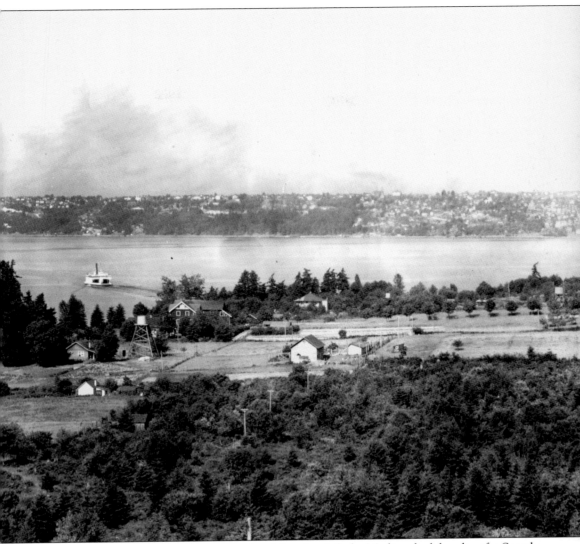

PANORAMA PART 2, DABNEY POINT. The *Leschi* has just left the Medina dock heading for Seattle. At this time, the *Leschi* served Medina en route from Meydenbauer Bay. In dating this panorama, the lake lowering of 1917 provides the upper bound and the *Leschi*, which started service in 1913, provides the lower bound. The imposing house to the left of center is "The Gables," Medina's first great mansion, built in 1908 and still standing today. Overlake Drive had not yet been laid out and would pass just to the right of the small building, to the lower right of center. (Courtesy of the Washington State Archives.)

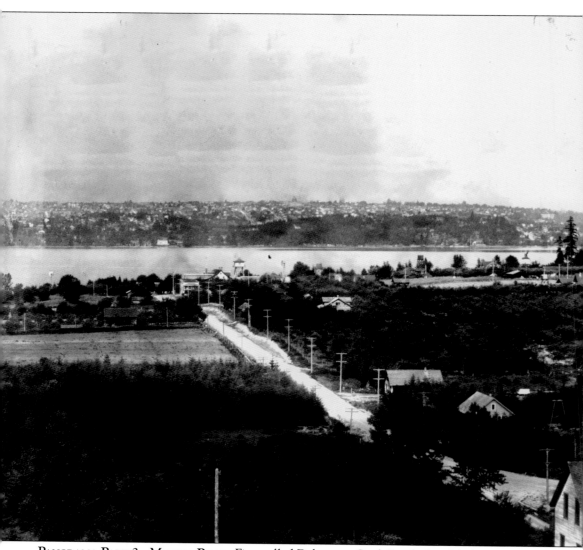

PANORAMA PART 3 , MEDINA ROAD. First called Dabney or Croft Road, then Medina Road, and now Eighth Street, this was Medina's first route leading from the original Dabney's Landing. In 1890, Thomas Dabney himself petitioned the county to build the road and was supported by about 15 other landowners. The large house with a white gable to the left center was the home of Capt. Elias Johnston and his wife, Maud. The Johnstons had acquired the property along the water from just north of Medina Road to past the site of the new ferry dock from Thomas Dabney in 1907. The Johnston home, described as a pagoda-style structure with 28 rooms, burned to the ground in 1929 and was not rebuilt. The Johnstons sold the property to H. F. Alexander, a "prominent shipping man." (Courtesy of the Washington State Archives.)

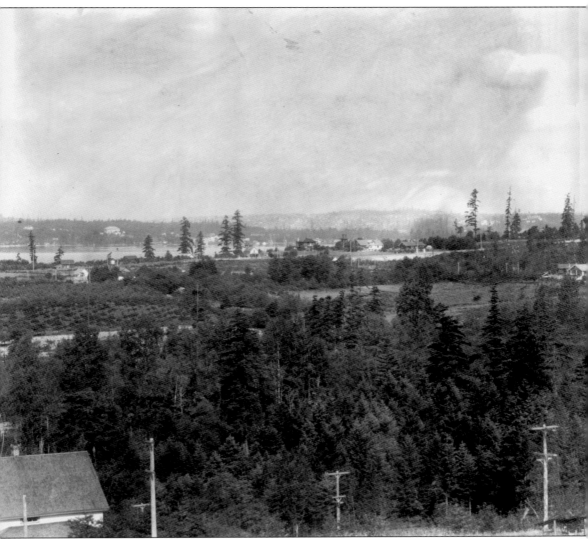

PANORAMA PART 4 , LOOKING NORTHEAST. The area in the center would be along Northeast Tenth Street, which, although some distance along rough roads from the ferry, did have homes as early as 1900. The utility poles in the lower part of the photograph would have been along Eighty-fourth Avenue, or Boddy Road, and the wooded area in the lower half would never develop and ultimately become Medina Park. Notable in all these photographs is the presence of water towers. Most homes had wells and those near the lake got water from there. The towers provided a ready water supply and some pressure at the tap. They also provided water for fighting fires, which, it seems, was a common task. (Courtesy of the Washington State Archives.)

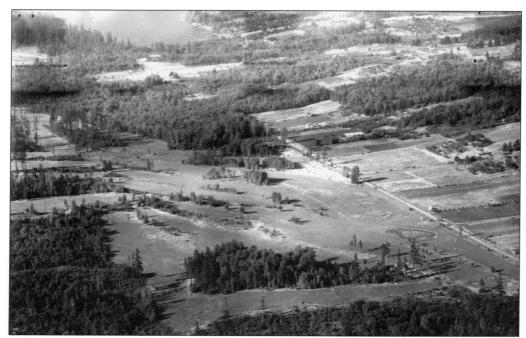

OVERLAKE GOLF COURSE. The Overlake Golf and Country Club golf course was laid out in 1925 on largely undeveloped land. The photograph above shows the Old Course, looking north, with Cozy Cove on the upper left. The east side of Boddy Road (now Eighty-fourth Avenue) had long been farmed, but much of the west side had drainage problems that made it unsuitable for farming. Note that the Old Course did not extend to the far northeast corner. The photograph below shows the new course, as designed in the early 1950s. Lower Clyde Hill remains agricultural and Norton Clapp's Medina Land Company, which continued to own the land under the course, had not developed the home sites along the perimeter. (Both courtesy of Overlake Golf and Country Club.)

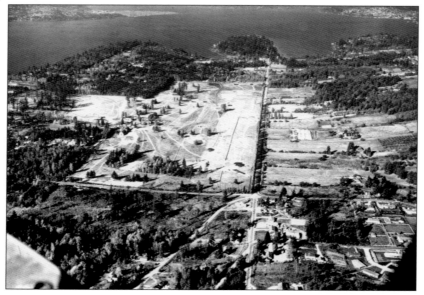

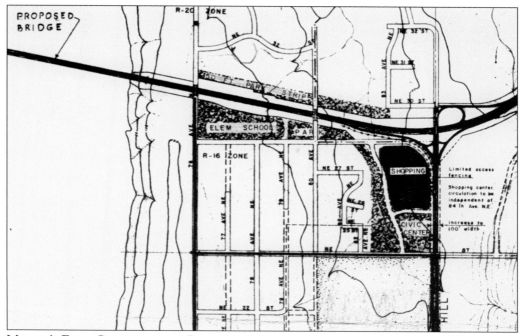

MEDINA'S FIRST COMPREHENSIVE PLAN, 1956. After incorporation, the new city did not waste any time in drawing up a comprehensive land use plan. The southern part of the city, seen below, developed largely along the lines of that first plan, even anticipating acquisition of Medina Park. In the north, however, several elements were discarded along the way. Most notably, the plan called for a civic center and shopping center along Eighty-fourth Avenue with service roads extending to Twenty-eighth Street. For the large wooded area between Twenty-eighth Street and Thirty-second Street, the plan designated the site of Three Points School but did not anticipate acquiring what is now Fairweather Nature Preserve. The plan shows the alignment of State Route 520 but assumes the ramps now at Ninety-second Avenue would be at Eighty-fourth Avenue. (Both courtesy of Elizabeth Park Luis.)

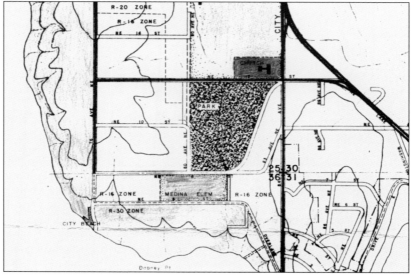

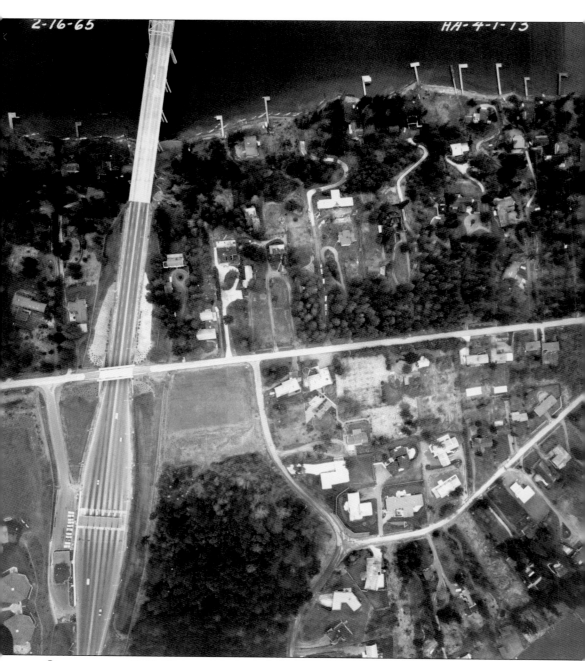

OVERHEAD IN 1965. This aerial view of the Evergreen Point Bridge toll plaza and adjacent neighborhoods shows how owners of properties on the beach below the bluff built serpentine driveways down the hill to avoid steps or trams. Where these driveways were not possible, owners built tramways that rode on cables strung from the top to bottom of the hill, many of which are still in use. This photograph shows that the grass field has been completed at Fairweather Park but not the tennis courts. (Courtesy of the Washington State Department of Transportation [WSDOT] collection, Washington State Archives.)

Two

BUSINESSES AND INSTITUTIONS

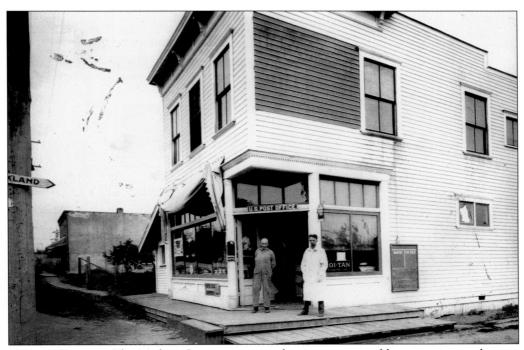

MEDINA GROCERY. The Medina Grocery remains the most recognizable institution in the city. It was built in 1908 and was shortly thereafter purchased by David Haggenstein, on the left, who operated it until 1918. David and his son Walter, on the right, ran the store and served as postmaster. In 1924, Walter returned to run the store and serve as postmaster into the 1950s. (Courtesy of the Washington State Archives.)

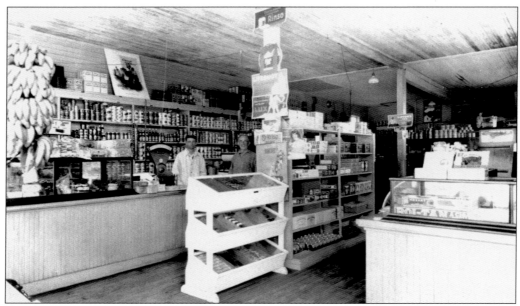

THE HAGGENSTEINS PROVIDE QUALITY SERVICE. When the Haggenstein family took over the grocery store shortly after its opening in 1908, there were only a handful of families living permanently in the area and roads to other settlements were poor. Nonetheless there were no other merchants in the area, and by providing delivery service—at first by donkey—the store survived. (Courtesy of the Eastside Heritage Center.)

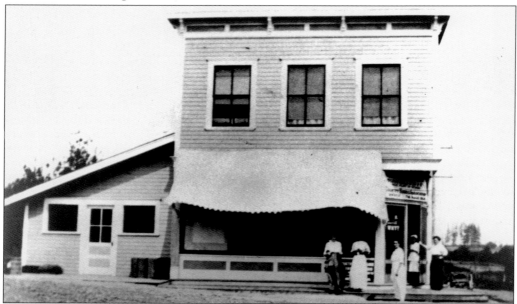

MEDINA GROCERY IN THE 1910S. This photograph would have been taken sometime between the addition of the shed wing on the left in 1911 and 1918 when the road in front was paved. The store did not always served as the post office, and in 1919 the store agreed to keep the post office only if residents stopped calling and asking for their mail to be delivered to their homes. (Courtesy of the Eastside Heritage Center.)

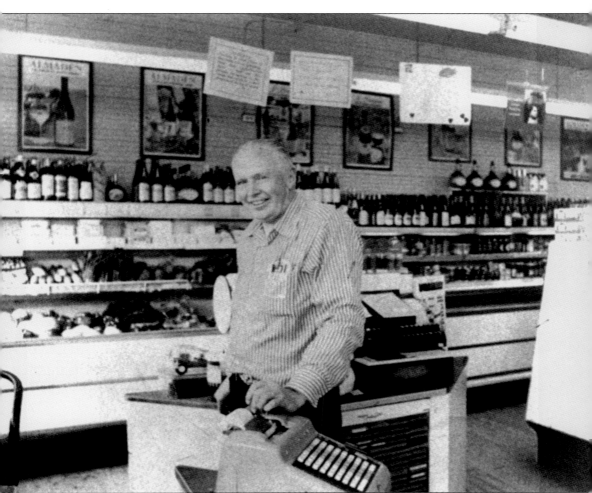

JOHN FROST, MEDINA LEGEND. John Frost, who had grown up in Medina, owned the store from 1952 to 1985. After serving in the U.S. Merchant Marine during World War II and working with his father in the landscaping business, Frost and a partner, Ken Marks, purchased the store in 1952. When the new partners took over, the store had been struggling to compete with new grocery stores in Bellevue. Soon, however, Frost bought out his partner and had the store up to 10 employees. Frost served for many years on the city council, but perhaps his best-known civic service was delivering important life lessons to children caught stuffing candy into their pockets. (Courtesy of the Eastside Heritage Center.)

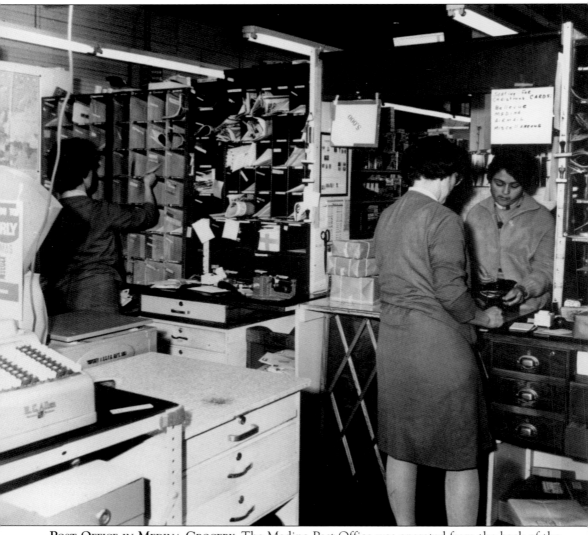

POST OFFICE IN MEDINA GROCERY. The Medina Post Office was operated from the back of the Medina Grocery until 1970. It transitioned from grocery employees to postal service employees but always remained a friendly alternative to the crowded Bellevue Post Office. Somehow it has managed to remain through many attempts by the U.S. Postal Service to eliminate small post offices. (Courtesy of the Eastside Heritage Center.)

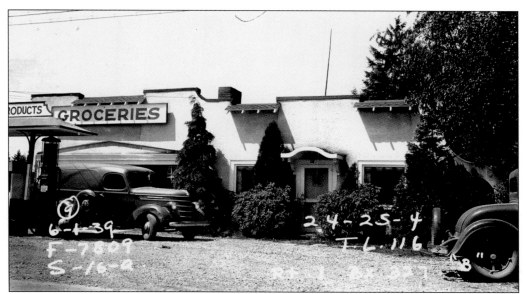

HUNTS POINT GROCERY. At the other end of town, in what is now Hunts Point, the Moorhead family ran this grocery and gas station. It stood at the corner of what is now Hunts Point Road and Hunts Point Circle. Located across the street from Bay School, it did a lively business in candy. (Courtesy of the Washington State Archives.)

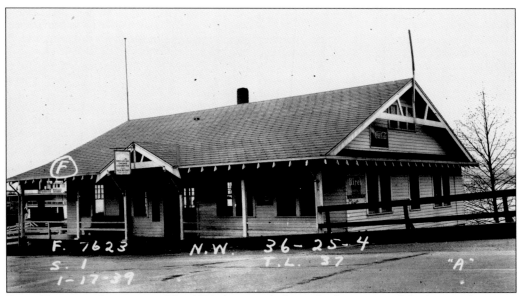

FERRY TERMINAL CONCESSION. This 1939 photograph shows the ferry terminal displaying advertising for the many goodies available from the concession inside, which included a lunch counter. The operator of the concession had attempted to build overnight cottages on land next to the terminal owned by the Medina Improvement and Good Roads Club, but the club turned him down, citing, among other concerns, the likely presence of liquor. (Courtesy of the Washington State Archives.)

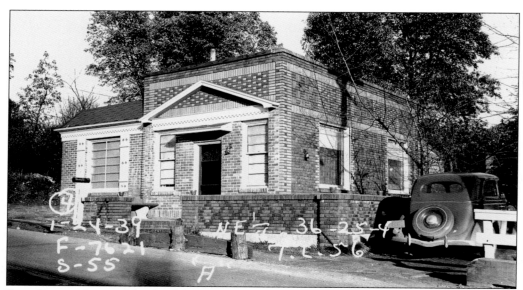

REAL ESTATE OFFICE. This brick building across from the ferry terminal was originally built as a real estate office for Sam Krueger. Upon its opening in 1928, the *Reflector* called it the "prettiest little real estate office in the world." It was later converted to a home. (Courtesy of the Washington State Archives.)

TELEPHONE EXCHANGE. Perhaps because phone company executive Edward Webster lived in Medina, the town had telephone service earlier than much of the Eastside. The telephone exchange building was built in 1917 and had up to 10 operators working various shifts. Later it was home to Walter Haggenstein as he continued to work as postmaster next door. It now serves as the post office for Medina, Washington 98039. (Courtesy of the Washington State Archives.)

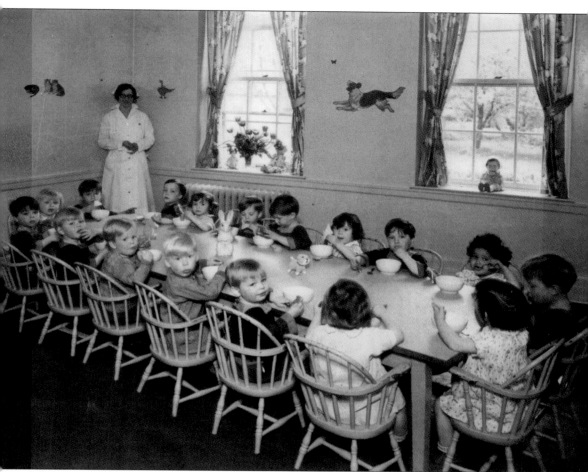

MEDINA BABY HOME. The Medina Baby Home was opened in 1921 in an existing house on Overlake Drive West at the Eighty-Fourth Avenue intersection. It would have been just up the hill from the old Eastland Wharf, although steamer service was rare by that time. The home operated as a traditional orphanage with a staff caring for children awaiting adoption. The home operated in Medina only until 1926. The agency moved to Seattle and shortly after shifted its emphasis to in-home foster care. It did, however, retain the name Medina Children's Services until 2004 when it changed its name to Amara. (Courtesy of Amara.)

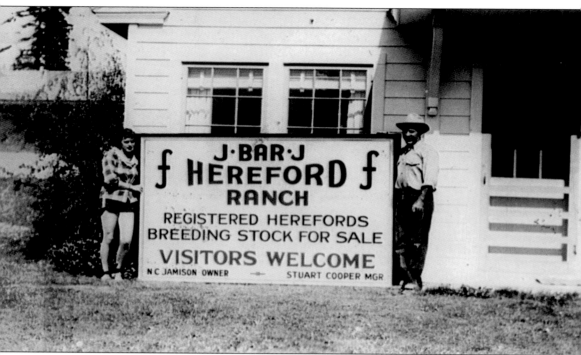

THE J BAR J RANCH. One of the more unusual businesses to open in Medina was the J Bar J Hereford Ranch, which operated on the property of the defunct Overlake Golf and Country Club. After the club closed in 1935, it was purchased by James and Charlotte Clapp, who raised Arabian horses on the property. The Clapps, in turn, sold the land to friend Neil Jameson, who raised cattle there from 1943 to 1950. After deciding to move his herd to the Ellensburg area, Jameson sold the property to James Clapp's younger brother, Norton Clapp, who made it available to a new generation of golfers who restarted the club. (Courtesy of the Washington State Archives.)

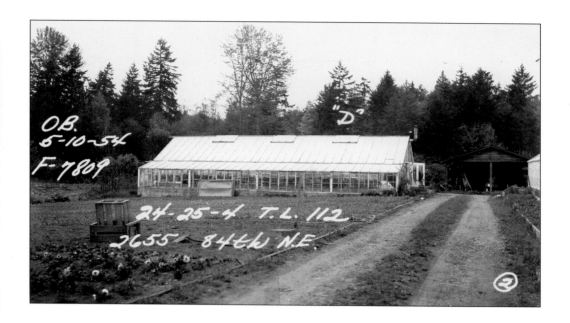

HUNTS POINT GREENHOUSES. Unlike neighboring Clyde Hill and Bellevue, Medina was never a major center of commercial agriculture. The exception to this was the Hunts Point Greenhouses and adjacent farm, which were located where the Medina Circle development is today. The greenhouses were built by the Boddy family, which had originally settled the area. They were later bought by the Yabuki family that operated them through the 1970s and also farmed the lowlands at the head of Fairweather Bay. Students from Medina and Three Points schools recall an annual trip to the Yabuki farm to pick pumpkins. (Both courtesy of the Washington State Archives.)

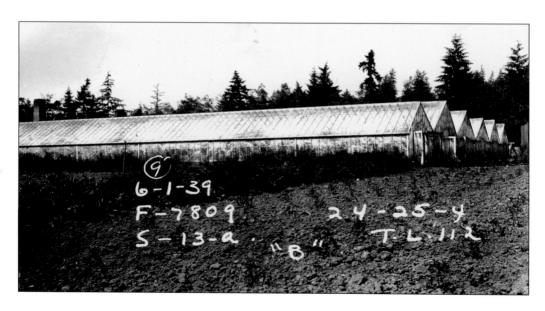

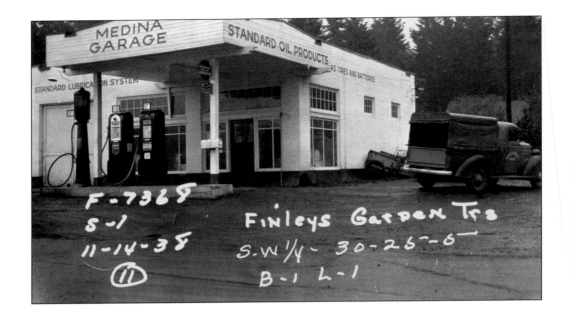

F-7368
S-1
11-14-38
⑪
Finleys Garden Trs
S.W ¼ - 30-25-5
B-1 L-1

MEDINA GARAGE. With the advent of car ferry service through Medina, a garage business along the Medina-Bellevue route was natural. The business was operated by Oscar Vollmer in the 1910s and 1920s and for many years by the Parent family, first by H. L. Parent, then by his son Ruley Parent. The picture above shows the garage in 1938 and the picture below shows it in 1954. The original St. Thomas Episcopal Church is seen in the background of the photograph below. (Both courtesy of the Washington State Archives.)

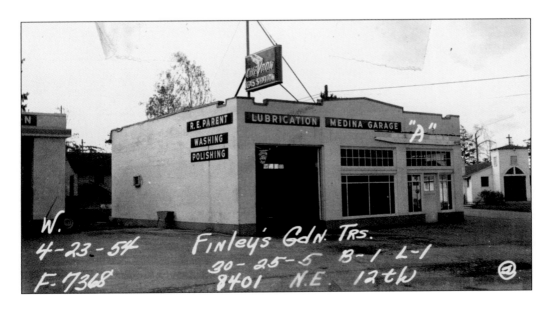

W.
4-23-54
F-7368
Finley's Gdn. Trs.
30-25-5 B-1 L-1
8401 N.E. 12th
㉑

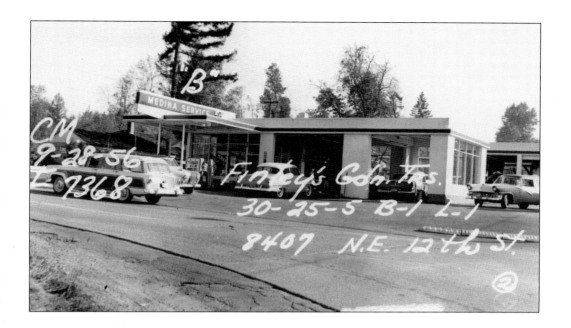

MEDINA CHEVRON. Today the Medina Chevron is a booming business with busy pumps and service bays. But things were not always so easy, especially when cars were still few. A 1918 advertisement in the *Reflector* claims, "We tackle everything from watches to submarines but we specialize in auto work." In 1927, the Parents added a blacksmith shop and rental cottages on the back of the property and operated the Cottage Grocery. The site also hosted a real estate office operated by C. A. Tolman. (Both courtesy of the Washington State Archives.)

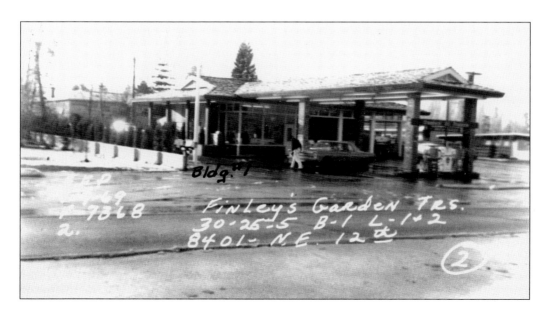

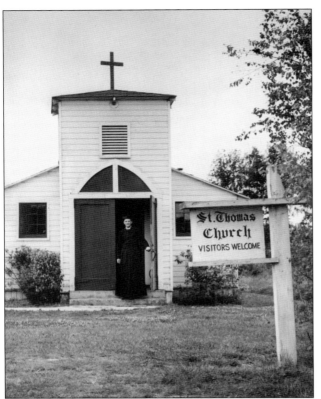

FIRST ST. THOMAS CHURCH. In 1944, a group of Medina and Points community residents petitioned the Episcopal bishop in Olympia to establish a church in the community, and the bishop responded by appointing Rev. Frederick Keppler to lead the new congregation. Services were initially held in the Medina Community Clubhouse—formerly the ferry terminal and now city hall—with the billiard table serving as an altar. Shortly after, parishioners found a surplus Civilian Conservation Corps schoolhouse in North Bend, which was moved to the triangular site between the Medina Garage and what is now Medina Park. Keppler left the parish in 1949 and was replaced by Rev. Arthur Vall-Spinosa, shown in the picture at left. (Left, courtesy of St. Thomas Episcopal Church; below, courtesy of the Washington State Archives.)

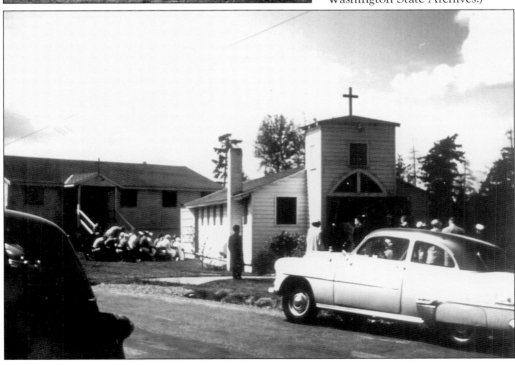

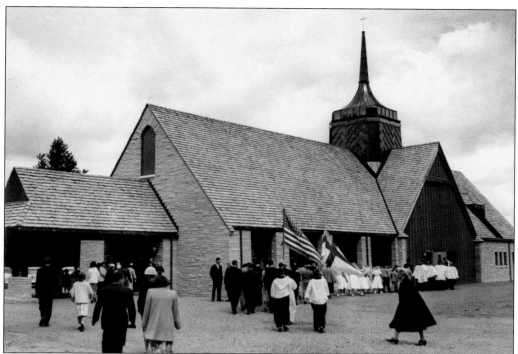

NEW ST. THOMAS CHURCH. When Norton Clapp bought the old Overlake Golf and Country Club property from the Jamesons after they moved their ranching operation to eastern Washington in 1950, he offered St. Thomas Episcopal Church as much land as it needed along the southern end of the property. Rev. Arthur Vall-Spinosa and his parish set to work on a new church, with ground breaking in July 1953 and dedication on June 27, 1954. As the photograph above shows, the transepts were not completed at the opening but were finished by 1957. The Great Hall, which still serves as a focal point for activities in Medina, was completed in 1955. (Both courtesy of St. Thomas Episcopal Church.)

Perhaps Medina's first permanent church, the Union Congregational Church (the sign above the entrance reads "Medina Community Church") sat across Boddy Road from the original Medina School, at what is now the corner of Eighty-fourth Avenue and Tenth Street. Originally called the Cottage Chapel, it was dedicated November 11, 1912. Early advertisements in the *Reflector* invite members of the community to services presided over by the pastor, Rev. J. B. Fenwick. The church was later converted to a home and is still standing. (Courtesy of the Washington State Archives.)

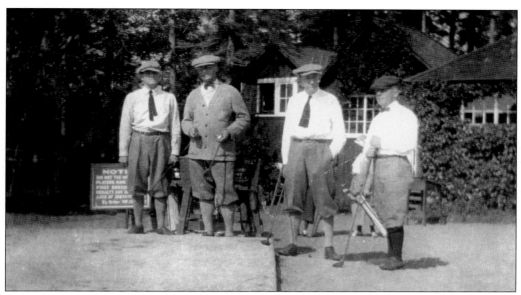

GOLFERS AT THE OLD COURSE AT OVERLAKE. The Overlake Golf and Country Club takes up a substantial portion of Medina's land area and is certainly its largest noneducational institution. Construction began in 1925 and the full 18-hole course was ready to play in 1927. A golf excursion to Overlake was popular in the late 1920s, so the *Leschi* ferry added special runs to accommodate golfers. (Courtesy of the Overlake Golf and Country Club.)

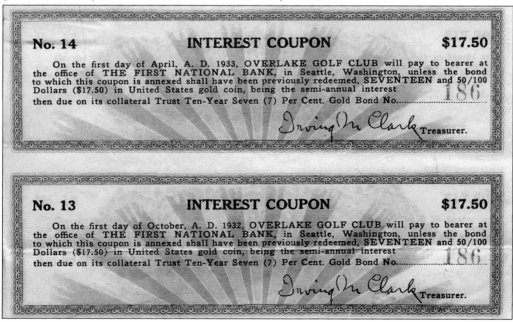

No. 14 **INTEREST COUPON** **$17.50**

On the first day of April, A. D. 1933, OVERLAKE GOLF CLUB will pay to bearer at the office of THE FIRST NATIONAL BANK, in Seattle, Washington, unless the bond to which this coupon is annexed shall have been previously redeemed, SEVENTEEN and 50/100 Dollars ($17.50) in United States gold coin, being the semi-annual interest then due on its collateral Trust Ten-Year Seven (7) Per Cent. Gold Bond No.............. 186

Irving M Clark Treasurer.

No. 13 **INTEREST COUPON** **$17.50**

On the first day of October, A. D. 1932, OVERLAKE GOLF CLUB will pay to bearer at the office of THE FIRST NATIONAL BANK, in Seattle, Washington, unless the bond to which this coupon is annexed shall have been previously redeemed, SEVENTEEN and 50/100 Dollars ($17.50) in United States gold coin, being the semi-annual interest then due on its collateral Trust Ten-Year Seven (7) Per Cent. Gold Bond No.............. 186

Irving M Clark Treasurer.

IOUs at Overlake. By the onset of the Great Depression, Overlake Golf and Country Club began to run into financial trouble. The club began to borrow from its members, using instruments like the one above, but in the end could not cover its debts. The course was foreclosed in 1935 and a prominent member, James Clapp, ended up buying it back for use as a horse-breeding ranch. (Courtesy of the Overlake Golf and Country Club.)

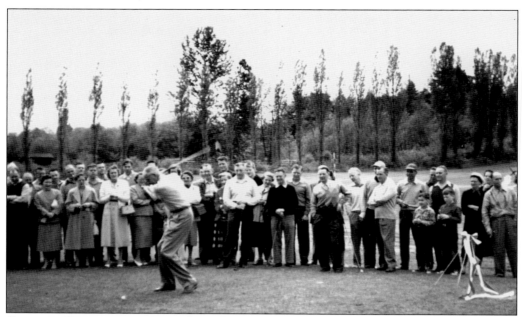

OVERLAKE REOPENS IN 1953. In the early 1950s, a new generation of Eastside leaders sought to reopen Overlake Golf and Country Club. The property was again in the hands of the Clapp family, and Norton Clapp agreed to favorable lease terms rather than allow the new club to go into debt as the original club had. The club began selling memberships in 1951 and the new course opened for play on June 27, 1953, with club president Stan Stretton taking the first swing in the photograph above. The new course was redesigned, as the old one was obliterated by 15 years of horses and cattle. It took a few years to get a clubhouse built, and in the meantime the club used the old farm buildings, including the horse and cattle barn, shown below, which was located about where the club's aquatic center is today. (Both courtesy of the Overlake Golf and Country Club.)

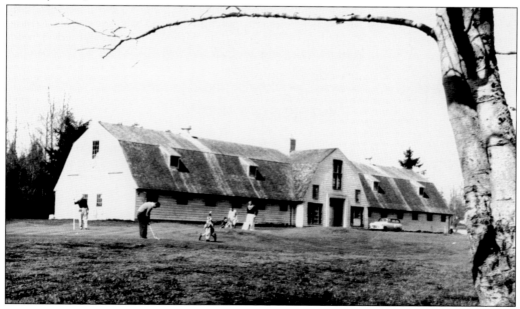

THE CLUBHOUSE. A major change in the design of the course was the placement of the clubhouse. The clubhouse on the old course was located near Evergreen Point Road, and the designers of the new course suggested the current location, to avoid a hill climb at the end. This photograph shows the new clubhouse at the foot of Northeast Sixteenth Street. (Courtesy of the Overlake Golf and Country Club.)

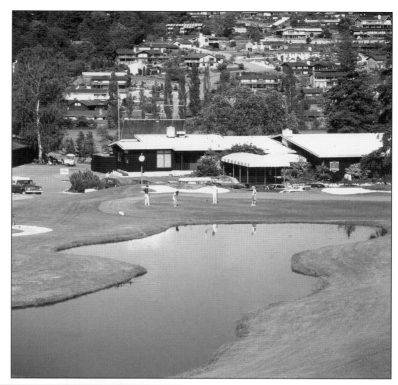

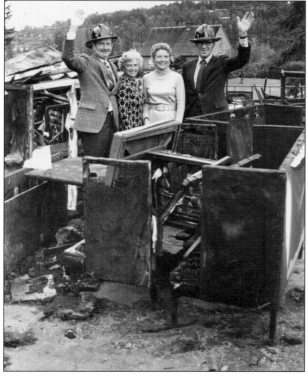

FIRE! Tragedy struck the Overlake Golf and Country Club the night of September 21, 1971, when an unknown arsonist set fire to the clubhouse. Most of the building was destroyed. The club came back, however, sponsoring a "Burned-out Ball" in November, cochairs of which are shown here. The clubhouse was rebuilt and expanded the next year. A brand new clubhouse was opened in 1993. (Courtesy of the Overlake Golf and Country Club.)

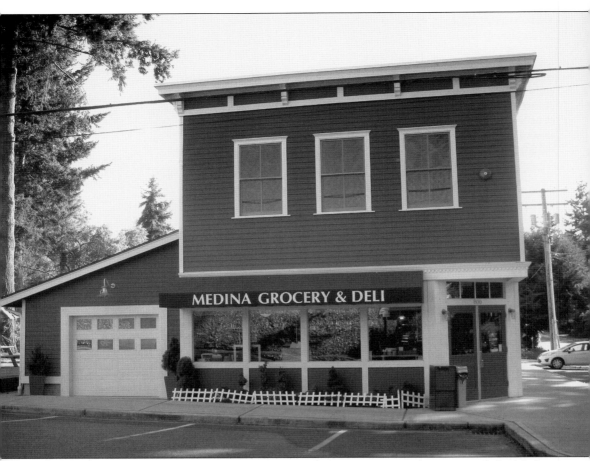

MEDINA GROCERY IS REBUILT. Medina always resisted any commercial zoning, and the Medina Grocery was grandfathered into a zoning code with the understanding that if it ever were removed, the land would revert to residential zoning. As the original building—which was never a sound structure to begin with—approached 100 years old, it was clearly crumbling and no restoration magic could bring it back. The owner of the property agreed to build a replica of the store, and after a challenging bit of back and forth between the city and the owner, the store reopened in 2008 and is once again the center of city life. (Photograph by the author.)

Three

GETTING TO AND AROUND MEDINA

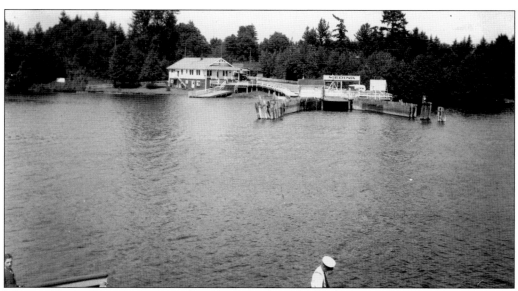

MEDINA FERRY TERMINAL, 1937. Until 1940, when the bridge opened across Mercer Island, ferries were the transportation backbone of Medina. Early roads did not lead to anywhere very helpful, while the booming city of Seattle was just a 10-minute ferry ride away. Car ferries served the terminal at Dabney Point, and a series of passenger steamers served docks along the shore. Because residents, rich and poor alike, could easily travel to jobs in Seattle aboard the *Leschi*, the *Ariel*, or other steamers, Medina shed its agricultural beginnings and evolved into a convenient commuter suburb. Today Medina sits in the exact center of the Puget Sound region's economic base, still offering easy commutes to the job centers of Seattle and the Eastside. (Courtesy of the King County Archives.)

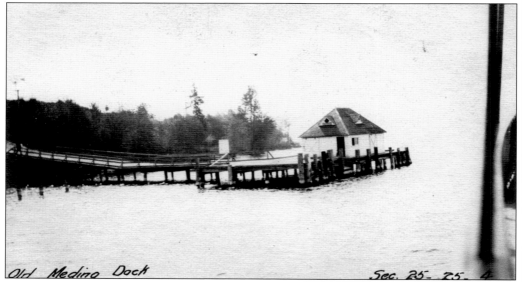

Old Medina Dock Sec. 25 - 25 - 4

OLD MEDINA DOCK, "DABNEY'S LANDING." The original Medina ferry dock stood at the foot of what is now Northeast Eighth Street on property originally owned by Thomas Dabney. Capt. Elias Johnston bought the land from Dabney in 1907, later reclaiming the right of way from King County as soon as the new ferry terminal was built down the shoreline at the end of Evergreen Point Road. (Courtesy of the King County Archives.)

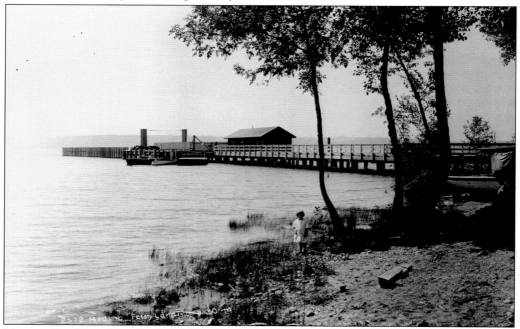

MEDINA CAR FERRY DOCK, 1914. This photograph shows Medina's first car ferry dock shortly after it opened. The waiting building on the dock was a source of irritation for the Ladies Auxiliary of the Medina Improvement and Good Roads Club, which tried to keep it clean and to keep people from writing on the walls. This dock was replaced when Lake Washington was lowered in 1917. (Courtesy of the City of Seattle Archives.)

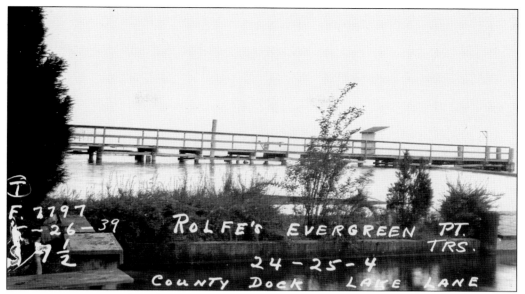

FAIRWEATHER DOCK. This pier, at the foot of Lake Lane on the east side of Evergreen Point, came into use in the 1930s when the original Fairweather Wharf at the head of the bay rotted away. It served the last of the lake steamers, the *Ariel*, until the Johnson brothers retired her in 1945. (Courtesy of the Washington State Archives.)

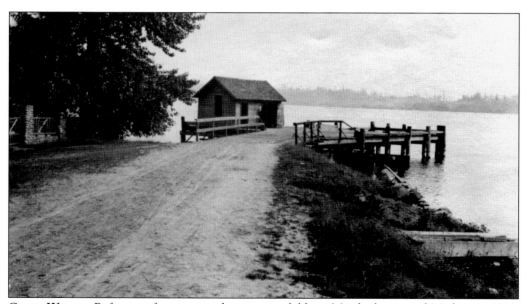

CLYDE WHARF. Before car ferry service became available at Meydenbauer and Medina in 1913, residents of Medina Heights found steamer service from this dock at what is now Clyde Beach. When car ferry service to Meydenbauer Bay stopped in 1919, steamer service resumed to the bay for a short period but proved uneconomic. (Courtesy of the King County Archives.)

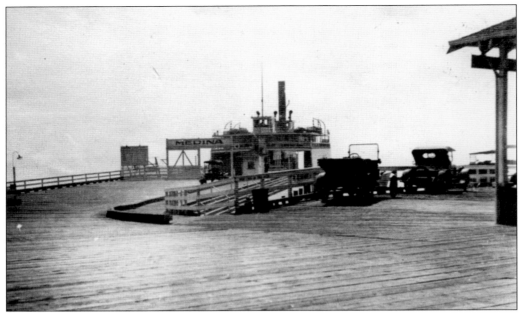

OLD CAR FERRY DOCK. The car ferry dock constructed after the lake was lowered in 1917 was built at a sharp right angle to the new ferry terminal building. This photograph from the early 1920s shows the *Leschi* with her original smokestack. (Courtesy of the City of Medina.)

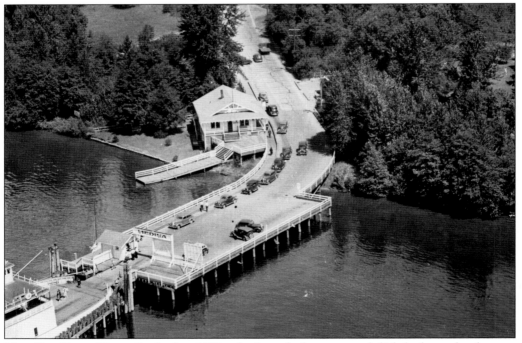

NEW CAR FERRY DOCK. In the late 1920s, the ferry dock was moved slightly down the shore to a position more in line with Evergreen Point Road. In this photograph from the mid-1930s, the entire old dock has been removed and replaced with a small float. (Courtesy of the Washington State Archives.)

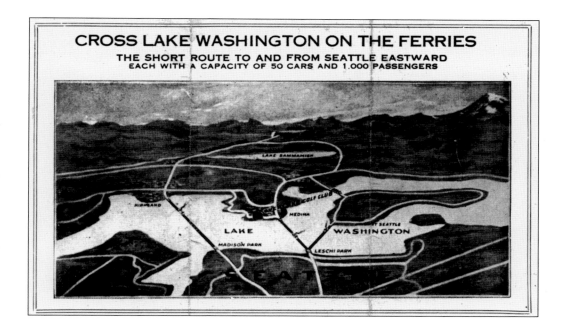

CROSS LAKE WASHINGTON ON THE FERRIES
THE SHORT ROUTE TO AND FROM SEATTLE EASTWARD
EACH WITH A CAPACITY OF 50 CARS AND 1,000 PASSENGERS

FERRY SCHEDULE. This schedule from 1930 shows regular car ferry service from Seattle to Mercer Island, Medina, and Kirkland. The map indicates that the Overlake Golf and Country Club was a major attraction, so the ferry schedule included special Saturday trips to Medina for golfers. The schedule also shows some of the Medina sailings made a stop at Roanoke, the dock on the northwest side of Mercer Island. (Both courtesy of Elizabeth Park Luis.)

LAKE WASHINGTON FERRIES
SCHEDULE EFFECTIVE DECEMBER 11, 1930

Mercer Island Route

Lv. Seattle Leschi Park	Lv. Roanoke
* 6:25 A.M.	* 6:40 A.M.
* 6:55 A.M.	* 7:15 A.M.
* 7:30 A.M.	* 7:50 A.M.
8:05 A.M.	8:25 A.M.
9:00 A.M.	9:15 A.M.
10:30 A.M.	10:45 A.M.
1:30 P.M.	1:45 P.M.
3:45 P.M.	4:00 P.M.
5:00 P.M.	5:15 P.M.
* 5:35 P.M.	* 5:50 P.M.
6:10 P.M.	6:25 P.M.
6:45 P.M.	7:00 P.M.
8:30 P.M.	† 8:40 P.M.
10:40 P.M.	10:55 P.M.
12:00 P.M.	† 12:10 A.M.

*Omitted on Sundays and Holidays.

† (Via Medina)

Automobile Rates

Light Car—2600 lbs. and under—
One Way....................50c
Round Trip.................75c
Heavy Car—Over 2600 lbs.—
One Way....................60c
Round Trip.................90c

Commutation Rates
Half of One-Way Fare
All Rates Include Driver

Seattle-Medina Route

Lv. Seattle Leschi Park	Lv. Medina
* 5:40 A.M.	* 6:00 A.M.
6:30 A.M.	6:50 A.M.
* 7:05 A.M.	* 7:25 A.M.
7:40 A.M.	8:00 A.M.
8:20 A.M.	8:40 A.M.
9:00 A.M.	9:15 A.M.
10:00 A.M.	10:15 A.M.
11:00 A.M.	11:15 A.M.
12:00 Noon	12:30 P.M.
1:00 P.M.	1:15 P.M.
2:00 P.M.	2:15 P.M.
3:00 P.M.	3:15 P.M.
4:00 P.M.	4:15 P.M.
5:00 P.M.	5:15 P.M.
5:35 P.M.	5:50 P.M.
* 6:10 P.M.	* 6:25 P.M.
6:45 P.M.	7:10 P.M.
7:30 P.M.	8:00 P.M.
8:30 P.M. (Via Roanoke)	9:00 P.M.
10:00 P.M.	10:20 P.M.
11:15 P.M.	11:35 P.M.
12:00 P.M. (Via Roanoke)	12:25 A.M.

*Omitted Sundays and Holidays.

Saturdays Only
Overlake Golf Club Special Trip
Lv. Seattle 12:30 P.M.
Lv. Medina 12:45 P.M.

Seattle-Kirkland Route

Lv. Seattle Madison Park	Lv. Kirkland
6:15 A.M.	* 5:45 A.M.
7:15 A.M.	6:45 A.M.
8:30 A.M.	7:45 A.M.
9:45 A.M.	9:10 A.M.
10:55 A.M.	10:20 A.M.
12:00 Noon	11:30 A.M.
1:30 P.M.	1:00 P.M.
2:30 P.M.	2:00 P.M.
4:00 P.M.	3:00 P.M.
5:15 P.M.	4:45 P.M.
6:05 P.M.	5:40 P.M.
7:00 P.M.	6:30 P.M.
8:00 P.M.	7:30 P.M.
9:00 P.M.	8:30 P.M.
10:30 P.M.	9:30 P.M.
12:00 P.M.	11:30 P.M.

*Omitted Sundays and Holidays.

Only 20 minutes crossing the lake to Kirkland.

J. L. ANDERSON, Operator
Leschi Park, Seattle
Phone EAst 5100

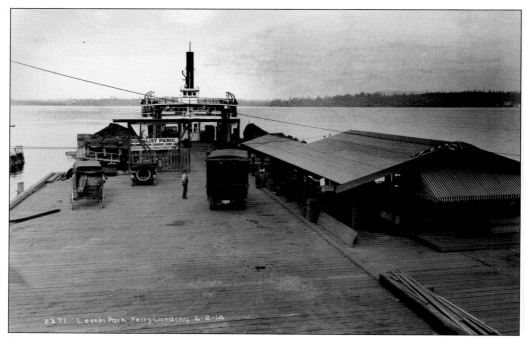

Ferry Dock at Leschi, Seattle. Car ferry service from Medina landed at the Leschi dock in Seattle. First a horse-drawn trolley and later a cable car took passengers directly to downtown Seattle, with a stop at Garfield High School along the way. (Courtesy of the City of Seattle Archives.)

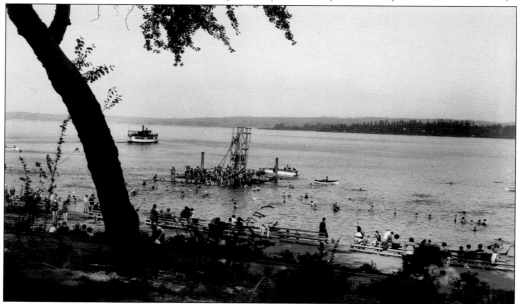

The *Ariel* Leaving Madison Park, Seattle. Car ferry service from Kirkland and passenger steamers from Houghton and the Points made their Seattle stop at the foot of Madison Street. In this photograph from 1930, the steamer *Ariel* has just departed the Madison Park dock headed to the Rom-No-Mor dock on Evergreen Point. The open water in this photograph is now crossed by the Evergreen Point Bridge. (Courtesy of the City of Seattle Archives.)

OLD CAR FERRY DOCK, 1932. Ferries were a great convenience for Medina and the Eastside, but the wharfs proved a major maintenance headache. The use of chemically treated lumber, which is mandatory today, was not common back then, resulting in docks regularly rotting. This photograph shows the old Medina dock after the new dock had been opened. A 1932 inspection report by the King County engineer that accompanied this photograph found the old dock in a "weak and decayed condition" and recommended removal if the dock could not be repaired. The county followed this recommendation and removed the old dock. (Courtesy of the King County Archives.)

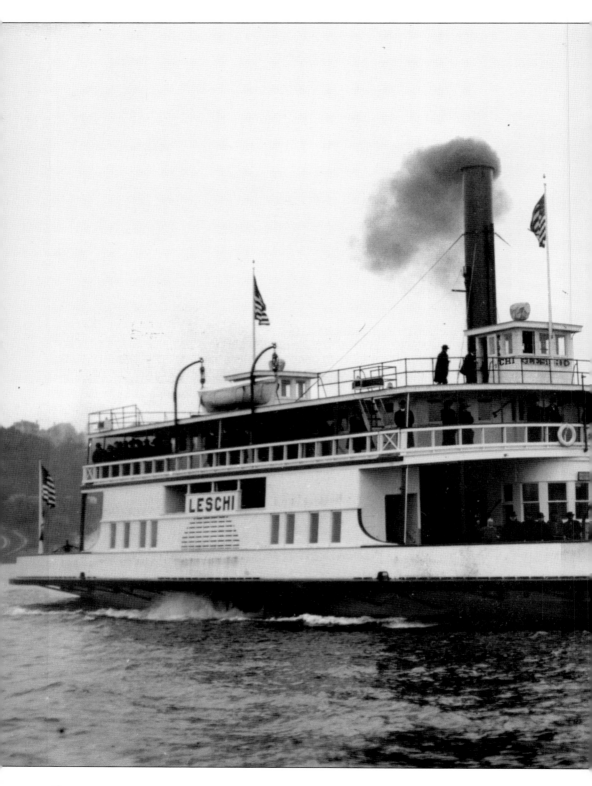

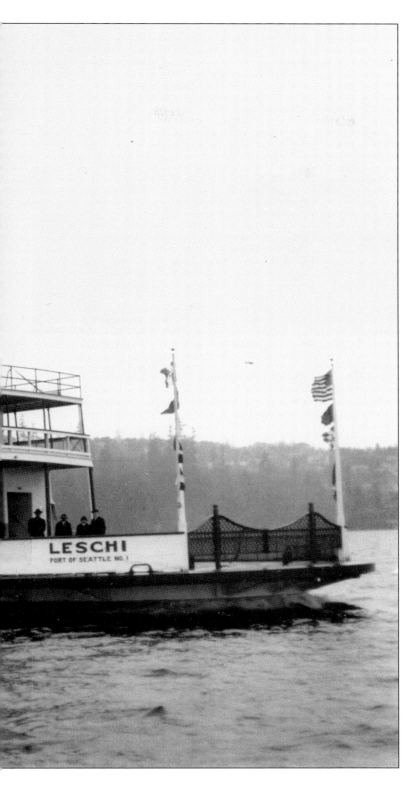

THE LESCHI. The *Leschi* was the only car ferry to provide regular service to Medina. Launched in 1913, she made her last run the day before the Mercer Island floating bridge opened in 1940. Before the Lake Washington ship canal opened in 1917, ferries either had to be built on the lake or brought up the Black River, which flowed through Renton. But no yards on the lake could build a steel hull and the *Leschi* would be far too big to drag over the sandbars of the Black River. The solution was to build the hull at a yard on the Duwamish River in Seattle, disassemble it, and haul the pieces to Rainier Beach for final assembly. The Port of Seattle commissioned the *Leschi*, but like almost all other lake ferries, she soon came under the control of Capt. John Anderson. (Courtesy of the Puget Sound Maritime Historical Society.)

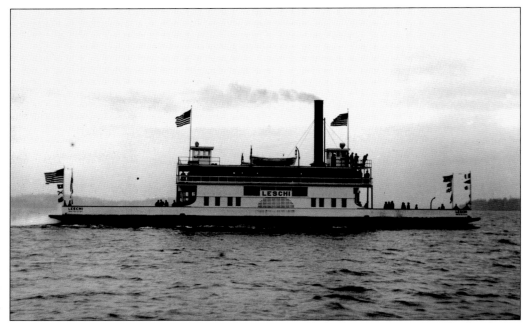

TRANSFORMATION OF THE LESCHI. The *Leschi* was originally built as a steam-powered side-wheeler with the side wheels inside, as seen in the photograph above. The side wheels, however, took up a large amount of space, lowering the ferry's automobile capacity. In 1930, Capt. John Anderson converted her to a propeller-driven diesel ferry with an increase in capacity. The picture below shows the new configuration with a shorter stack and overhead passenger ramps. When the Mercer Island Bridge opened in 1940, Anderson shifted the *Leschi* to the Madison Park-Kirkland run, ferrying shipyard workers to Houghton during the war. After ending her service on Lake Washington in 1950, the *Leschi* became part of the Washington State ferry system and was sold in 1969 for conversion to a floating fish cannery in Prince William Sound, Alaska. (Both courtesy of the Puget Sound Maritime Historical Society.)

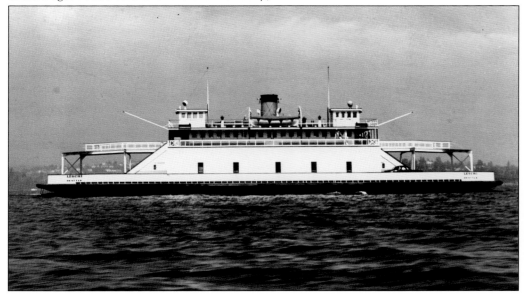

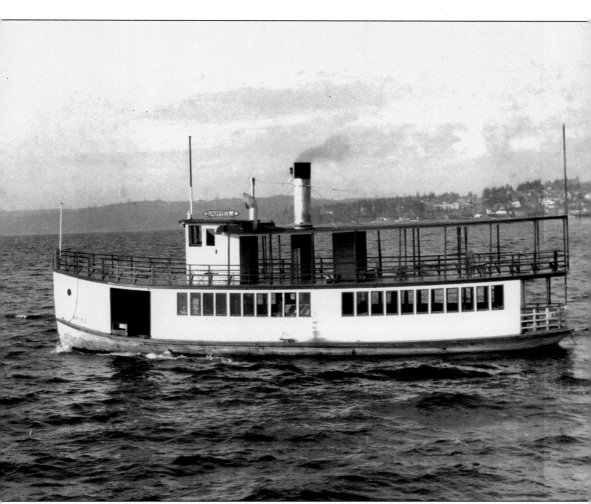

THE STEAMER ARIEL. The *Ariel* was one of the few successful vessels on Lake Washington not under the control of Capt. John Anderson. Heinie and Marcus Johnson bought her in 1914 and moved her to Lake Washington in 1921, where she served stops between Houghton and Madison Park, including Fairweather Bay and Evergreen Point. The brothers kept the business going in the north end of Medina after the Mercer Island Bridge opened in 1940 and brought car ferry service to the south part of Medina to a halt. In 1945, facing a combination of too few passengers and a condemned boiler, the Johnsons were forced to retire the Ariel, ending passenger steamer service on Lake Washington. She was later converted to a floating home in Portage Bay for University of Washington students. (Courtesy of the Puget Sound Maritime Historical Society.)

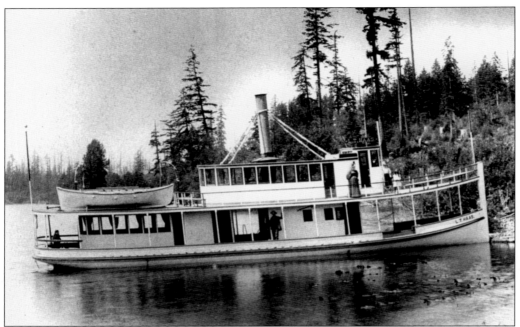

THE STEAMER *L. T. HAAS* AND *DAWN*. While the *Leschi* and just a handful of other auto ferries served Lake Washington, dozens of passenger steamers worked the routes among the many formal wharfs and informal flag stops along the shores of Mercer Island and the Eastside. The *L. T. Haas* (above) was built in the late 1800s and served Medina and Bellevue from Leschi. The *Dawn* (below) spent most of her life on the run between Leschi and Roanoke, on Mercer Island, but also served docks on the southern part of Medina. (Above, courtesy of the Puget Sound Maritime Historical Society; below, courtesy of the Eastside Heritage Center.)

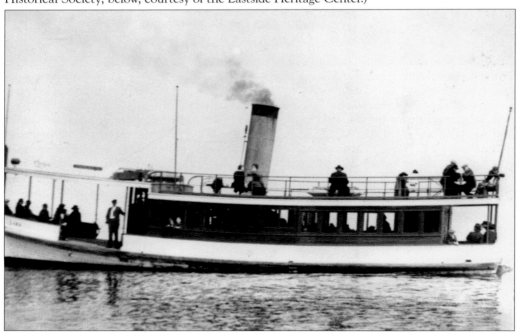

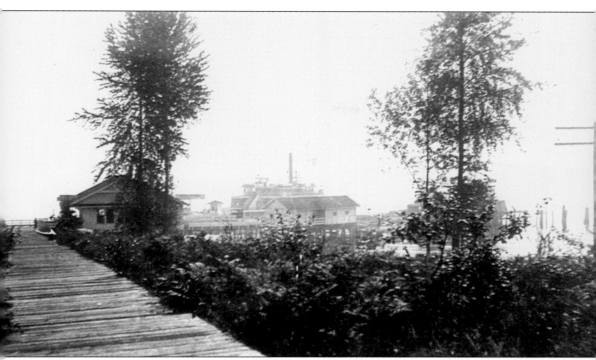

BOARDWALK TO THE FERRY. While the lake ferries connected to paved streets and streetcars on the Seattle side, roads on the Eastside were still rough. This undated photograph shows the boardwalk that provided safe footing between the Medina Grocery and the ferry terminal. Like the dock itself, the boardwalk seems to have been in a constant state of disrepair and a regular source of discussion by the Medina Improvement and Good Roads Club. The club occasionally succeeded in getting King County to provide lumber for repairs but often had to round-up volunteer labor. (Courtesy of the City of Medina.)

UNPAVED EVERGREEN POINT ROAD. This photograph from about 1918 shows an unpaved Evergreen Point Road in front of the grocery and newly built telephone exchange (now the post office). Building roads was second only to schools as a concern of early residents, but while a local district could erect schools with local levies, building roads required a petition to the County. When the county did build a road, it was unpaved, leaving the costly paving to a future petition. A lively debate arose in 1918 over whether Hindle Road (now Evergreen Point Road) or Boddy Road (now Eighty-fourth Avenue) should have priority for paving. The Boddy road faction claimed it would provide a "quicker, shorter, more economical connection to the ferry," whereas the Hindle Road proponents argued for a more scenic link to Lake Washington Boulevard rather than a route through a "low, unsightly, uninhabited" valley. Hindle Road won that year but the county paved Boddy Road in 1921. (Courtesy of the City of Medina.)

BOARDWALK ON EVERGREEN POINT. This undated photograph shows a boardwalk that ran along the shoreline north from Dabney's Landing, providing access to lakefront property. (Courtesy of the City of Medina.)

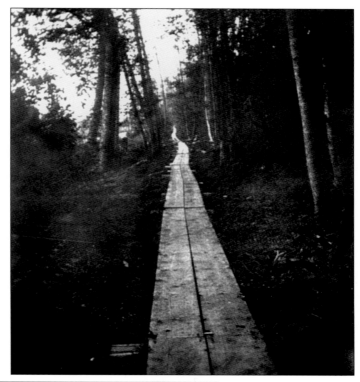

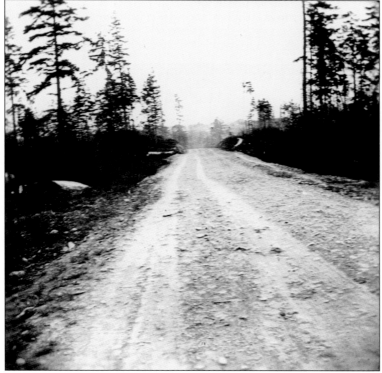

NORTHWEST HINDLE ROAD. Hindle Road consisted of most of Evergreen Point Road up to Twenty-fourth Street, and then Twenty-fourth Street itself to Boddy Road, which is now Eighty-fourth Avenue. This photograph shows the early, unpaved road, looking east along Twenty-fourth Street from about Seventy-seventh Avenue. The plat for Herron's Addition later named that stretch of road Madison Boulevard. (Courtesy of the City of Medina.)

FRANCIS BODDY ROAD. The Boddy family settled the area around the base of Hunts Point and proceeded to name things after themselves, including roads and even the census tract. Francis Boddy Road lies along what is now Eighty-fourth Street and extended all the way to the Eastland Wharf (now the city dock near Groat Point). It was originally established as a dirt track in 1898, as seen in these photographs, but was expanded in 1918 as property owners on both sides contributed land for the right-of-way. The picture above looks north from Twenty-fourth Street. The picture below is not labeled but the location notes indicate it is in the same general area. (Both courtesy of the King County Archives.)

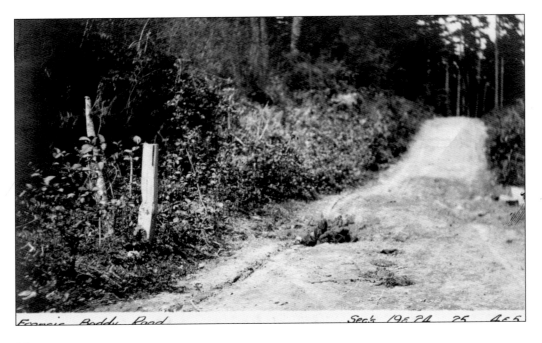

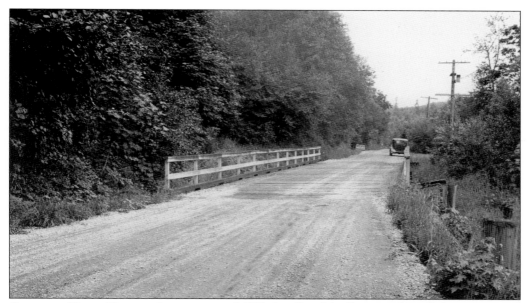

OVERLAKE DRIVE TRESTLE. It was not until 1921 that Overlake Drive made it all the way around Groat Point and connected with Lake Washington Boulevard. These two trestles bridged gullies on the east side, above Meydenbauer Bay, and newer versions are still in place along Overlake Drive East. (Courtesy of the King County Archives.)

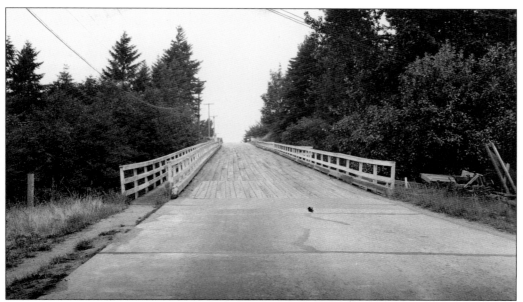

MEYDENBAUER BRIDGE. Lake Washington Boulevard, along Meydenbauer Bay, provided the critical link between Medina and Bellevue. Once this link was complete, Bellevue drivers began heading to the ferry dock in Medina, bypassing the dock in Meydenbauer and ultimately leading to the end of ferry service to Bellevue. This 1932 photograph shows an early version of the bridge across what is now Meydenbauer Park. (Courtesy of the King County Archives.)

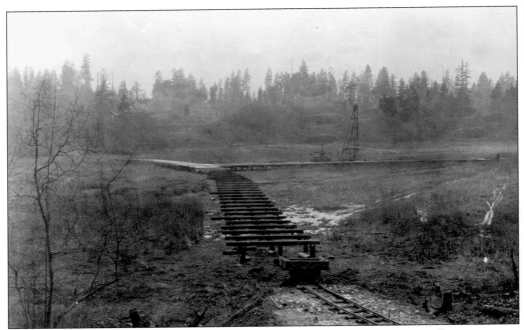

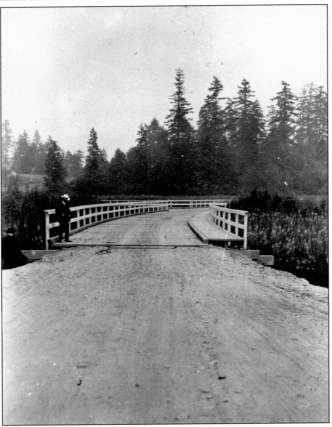

BODDY-HINDLE TRESTLE IN 1918. Before the current yacht basin was built at the head of Fairweather Bay in the late 1950s, the area was a reedy wetland. In 1918, the county built the Boddy-Hindle trestle as a link to a ferry wharf the county determined it needed in Fairweather Bay. The photograph above shows the trestle under construction in 1918, looking west from the base of Hunt's Point. In the middle of the photograph can be seen a branch trestle that led to the wharf. The photograph below shows the trestle shortly after opening, looking from Medina towards Hunt's Point, with the wharf extension to the left. (Both courtesy of the King County Archives.)

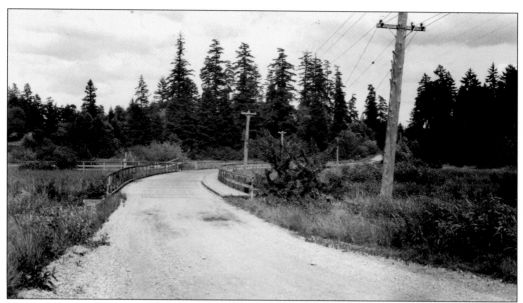

BODDY-HINDLE TRESTLE. This photograph shows the trestle much-aged. In 1944, the county removed the trestle and replaced it with fill dirt excavated during the construction of Northeast Twenty-eighth Street. The Fairweather yacht basin, dredged in the late 1950s, eliminated the road altogether, and the west side of the basin remains part of Hunt's Point even though it is accessible only through Medina. (Courtesy of the King County Archives.)

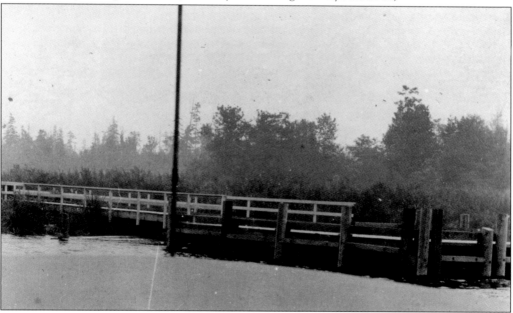

FAIRWEATHER BAY WHARF. This undated photograph shows the wharf at the end of the spur off the Boddy-Hindle trestle. The wharf would have been served by ferries on the Three Points routes between Houghton and Madison Park. A county inspection report from 1930 found the wharf almost completely rotted, and a report from 1940 indicates that the wharf had totally disappeared. (Courtesy of the King County Archives.)

NORTHEAST TWENTY-SECOND STREET IN 1920. This photograph from about 1920 looks east from Evergreen Point Road, showing homes along what is now Northeast Twenty-Second Street. The Herron's Addition plat named it Madrona Street to go along with Maple Street and Cedar Street (now Twenty-sixth Street and Twenty-eighth Street, respectively). Avenues were named after presidents Washington, Monroe, Adams, and Jackson. These names were used until at least the 1930s. (Courtesy of Elizabeth Park Luis.)

EVERGREEN POINT ROAD. Evergreen Point Road from Twenty-fourth Street nearly to the end of Evergreen Point was paved in 1931. This photograph from that year looks north from about Twenty-second Street, showing a relatively sparsely populated area even then. Legend has it that an influential figure had a summer home on the Point and secured funds to pave the lightly used dead-end street while other heavily used streets remained unpaved. (Courtesy of Elizabeth Park Luis.)

Four

THE STATE ROUTE 520 CORRIDOR

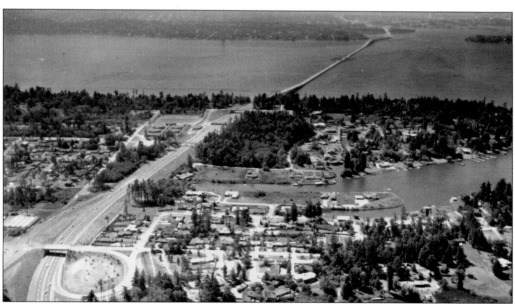

STATE ROUTE 520 CUTS THROUGH MEDINA. No project, before or since, has had as big a physical impact on Medina as the State Route 520 project. Although the property it used was largely uninhabited and few people were displaced, the new highway split the city in two and introduced a roar of traffic noise that can be heard throughout the area. This photograph from 1965 shows the footprint of the east approaches, the toll plaza, and the Eighty-fourth Avenue interchange. The upcoming bridge replacement project will bring lids to Evergreen Point Road and Eighty-fourth Avenue but will leave most of the existing corridor untouched. (Courtesy of the WSDOT collection, Washington State Archives.)

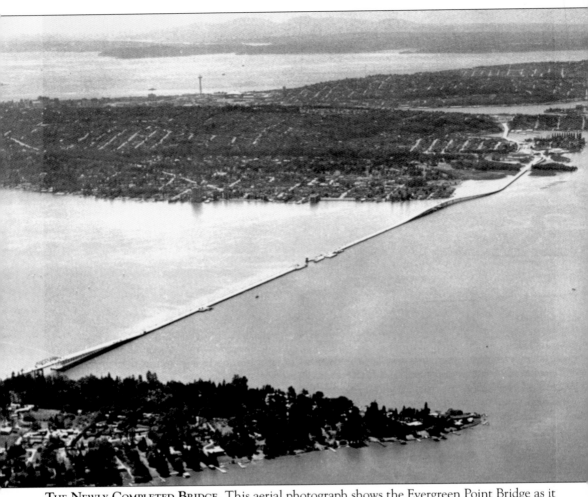

THE NEWLY COMPLETED BRIDGE. This aerial photograph shows the Evergreen Point Bridge as it nears completion in 1963. The draw span was later fitted with wings to guide vessels through the opening. (Courtesy of the WSDOT collection, Washington State Archives.)

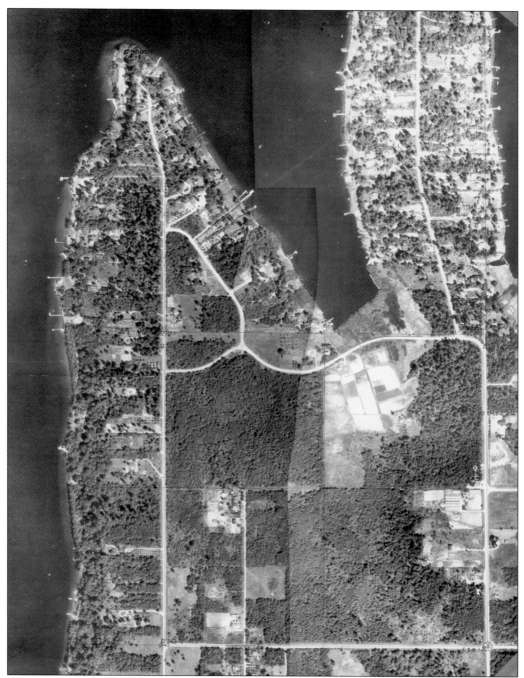

PRE-BRIDGE. This aerial photograph was taken in 1937. Although 20 years would pass before construction began, the area changed little in that time. Of the wooded area in the center, the north half became Fairweather Nature Preserve. The farmed area to the right of center was dredged and formed into the Fairweather Yacht Basin just prior to construction of the bridge. (Courtesy of the King County Roads Division.)

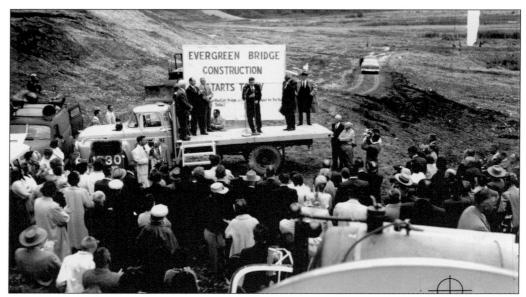

GROUND BREAKING. Dignitaries gather at Yarrow Bay for the ground-breaking ceremony for the State Route 520 Corridor in the fall of 1960. The project began 11 years after the first study of cross-lake traffic. The bridge across Mercer Island had only been open nine years at that point, but the Eastside was growing rapidly. The state ultimately rejected the idea of a second Mercer Island bridge or a Sand Point-Kirkland route. (Courtesy of the WSDOT collection, Washington State Archives.)

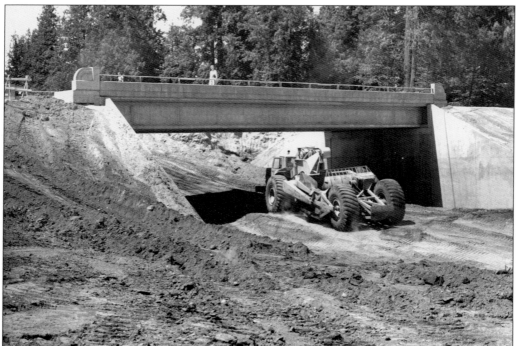

EVERGREEN POINT ROAD OVERPASS. The overpass is complete and a grader is moving earth for the final roadbed. (Courtesy of the WSDOT collection, Washington State Archives.)

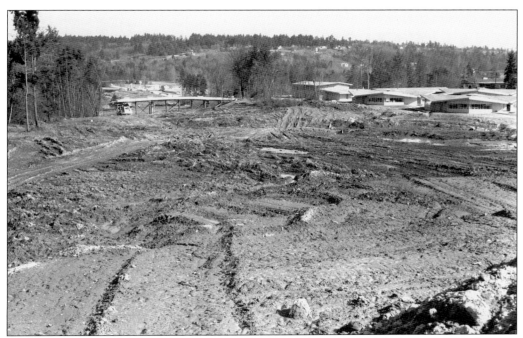

GRADING THE TOLL PLAZA AREA. This photograph shows the grading of the large area that became the toll plaza. Three Points School, which opened in 1961, is in the background. (Courtesy of the WSDOT collection, Washington State Archives.)

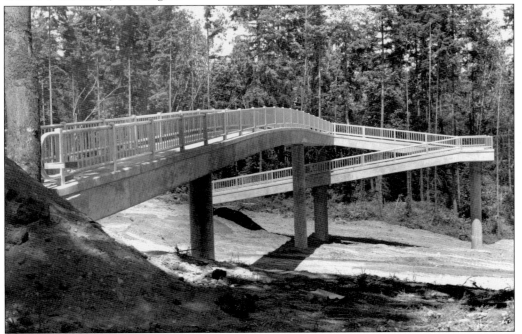

PEDESTRIAN OVERPASS. This pedestrian overpass links Three Points School with the footpath along the north side of the freeway. (Courtesy of the WSDOT collection, Washington State Archives.)

CONSTRUCTION COSTS and CONTRACTORS

COSTS—LAKE WASHINGTON FLOATING BRIDGE—ROANOKE EXPRESSWAY—EAST APPROACHES

Job Description	Contractor	Cost
Second Lake Wash. Bridge Unit 1—Floating structure	Guy F. Atkinson Company	$10,969,596.95
Second Lake Wash. Bridge, E. and W. Approaches	General Constr. Co. and Manson Const. & Engr. Co.*	$ 3,518,767.00
Roanoke Expressway—Portage Bay Viaduct	Western Bridge Company*	$ 2,291,805.00
10th Ave. N. to Delmar Drive	N. Fiorito Co., Inc.	$ 798,557.15
Arboretum Interchange	General Constr. Co. and Manson Constr. & Engr. Co.	$ 4,547,196.50
R. H. Thomson Expressway—Temporary connection	Bocek Bros.	$ 250,256.00
Roanoke Connection to Second Lake Wash. Bridge—Illumination	Van S. McKenny Co. Inc.	$ 72,938.00
Roanoke Connection to Evergreen Point Bridge—Signing	Fentron Industries, Inc.	$ 72,789.45
	TOTAL	$22,521,906.05

COSTS—TOLL FACILITIES FOR SECOND LAKE WASH. BRIDGE

Job Description	Contractor	Cost
Evergreen Point Bridge Toll Plaza—Administration Building	Mowat Bros. Constr. Company	$ 173,264.19
Evergreen Point Bridge—Toll collection equipment	Taller & Cooper, Inc.	$ 94,500.00 (C)
East Approach to Evergreen Point Bridge—Manual sprinkler	Finn Hill Nursery	$ 4,967.00 (C)
	TOTAL	$ 272,731.19

COSTS—LAKE WASHINGTON FLOATING BRIDGE—EAST APPROACHES

Job Description	Contractor	Cost
E. Approach to Evergreen Point Bridge—Clear, drain, grade, erosion control, surface, pave and fence 1.9 miles. Construct 3 reinforced concrete bridges	Northwest Constr. Co.	$ 1,387,091.85 (C)
E. Approach Evergreen Point Bridge—Signing	Traffic Safety Supply Co.	$ 13,736.39 (C)
Yarrow Bay Interchange—Clear, drain, grade, erosion control, surface, pave and fence 0.2 miles. Construct 1 bridge	Northwest Constr. Co.	$ 659,646.60 (C)
E. Approach to Evergreen Point Bridge—Install illumination on east approach to second lake bridge	Chapman Electric	$ 14,889.00 (C)
Northrup Way—Sprinklers	Bellevue Bulldozing Inc.	$ 111,287.30 (C)
Yarrow Bay—Illumination		$ 29,150.00 (C)
	TOTAL	$ 2,215,801.14

(C) Project not completed—final estimate not available—This is the contract bid price.

SEATTLE FREEWAY—N.E. 75th ST. TO RAVENEA BLVD.	$ 6,011,315.05
SEATTLE FREEWAY—E. SHELBY ST. TO RAVENNA BLVD.	$15,889,554.84
SEATTLE FREEWAY—E. MERCER TO E. SHELBY STREET	$16,602,016.28
LAKE WASHINGTON FLOATING BRIDGE—ROANOKE EXPRESSWAY—EAST APPROACHES	$22,521,906.05
SEATTLE FREEWAY—OLIVE WAY TO N.E. 75TH ST., SIGNING	$ 271,970.07
TOLL FACILITIES FOR SECOND LAKE WASHINGTON BRIDGE	$ 272,731.19
LAKE WASHINGTON FLOATING BRIDGE—EAST APPROACHES	$ 2,215,801.14
CONSTRUCTION TOTAL	$63,785,294.62

PAYING FOR IT ALL. The final costs of the corridor seem almost laughably low by today's standards. The freeway through Yarrow, Hunts Point, and Medina cost just $2.2 million and the entire corridor was built for $25 million—$190 million in today's dollars. In contrast, the new replacement bridge is estimated to cost $4.7 billion. (Courtesy of the WSDOT collection, Washington State Archives.)

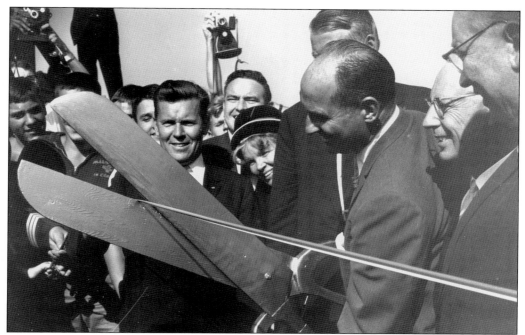

CUTTING THE RIBBON. Gov. Albert Rosellini, above, cuts the ribbon on the bridge that would later bear his name. Seattle mayor Gordon Clinton stands to the governor's right. Although he looks happy in this photograph, Mayor Clinton had consistently opposed the Montlake-Evergreen Point route, favoring a parallel bridge across Mercer Island as well as a Sand Point-Kirkland bridge. (Courtesy of the WSDOT collection, Washington State Archives.)

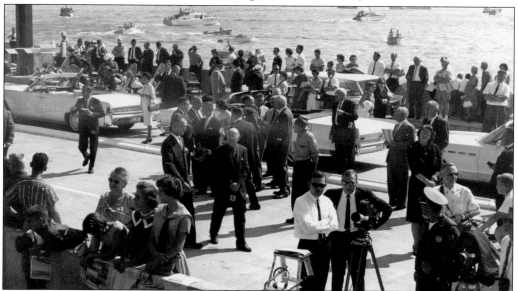

OPENING CEREMONIES. The Evergreen Point Bridge opened to traffic following a mid-span ceremony on August 28, 1963. Dignitaries were seated on a barge moored to the bridge, and thousands of observers walked on the bridge deck before a grand parade completed the crossing. (Courtesy of the WSDOT collection, Washington State Archives.)

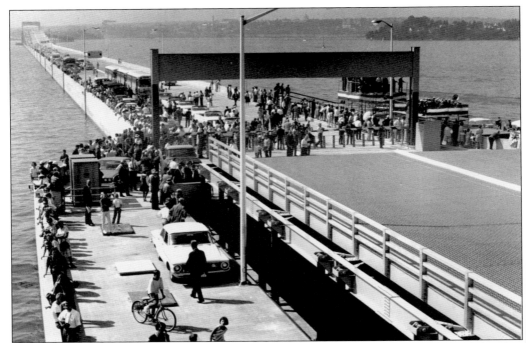

DEMONSTRATING THE DRAW SPAN. Though never as industrial as the builders of the ship canal anticipated, Lake Washington remains a navigable waterway, and the new bridge had to accommodate vessels larger than what might fit under the high rises. In this picture, opening day crowds see a demonstration of the draw span: center pontoons slide under a raised bridge deck to create an opening. (Courtesy of the WSDOT collection, Washington State Archives.)

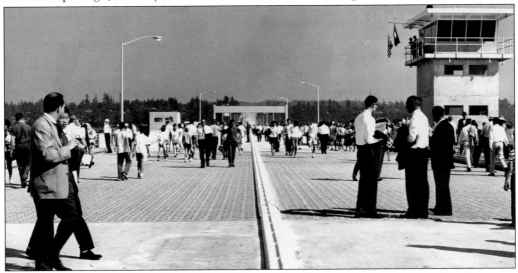

NO BARRIERS. The bridge deck originally had only a low C-curb separating lanes of traffic. Jersey barriers were added in the 1970s but did not cover the draw span. Later, with the draw span being used only a few times a year, the state added movable barriers to it. Originally designed for relatively quick openings, use of the draw span is now a major undertaking. (Courtesy of the WSDOT collection, Washington State Archives.)

FLATS AND EMPTY TANKS. State highway director Walt McKibbon, on the right, talks to highway department personnel about two things that would go wrong most often on the new bridge: flat tires and empty gas tanks. The new bridge lacked shoulders for breakdowns, however, and the consequent back-ups from stalled vehicles blocked lanes. (Courtesy of the WSDOT collection, Washington State Archives.)

SAFETY TELEPHONES. One prominent feature of the new bridge was the placement of emergency telephones at regular intervals, as demonstrated by the "stranded motorist" in this photograph. As real stranded motorists found out, however, the phones simply connected to the administration building in Medina and not directly to anyone who might be able to help. (Courtesy of the WSDOT collection, Washington State Archives.)

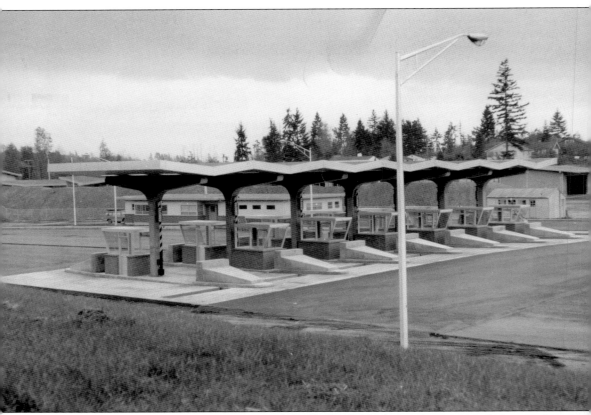

TOLLS ON THE BRIDGE. Because it was not a federally funded highway, the state needed to pay for the bridge with tolls: 35¢, later reduced to 10¢ for carpools. Commuters could buy tickets for 19¢ each. In the mid-1970s, a group of toll collectors were caught embezzling cash tolls; each time a driver paid 35¢, they pocketed the coins and substituted a ticket they had purchased. The 16¢ profit on each swap added up to thousands of dollars. The state later moved the lighted signs that showed what toll was paid from the side of the toll booth to a position in front of the vehicle. (Courtesy of the WSDOT collection, Washington State Archives.)

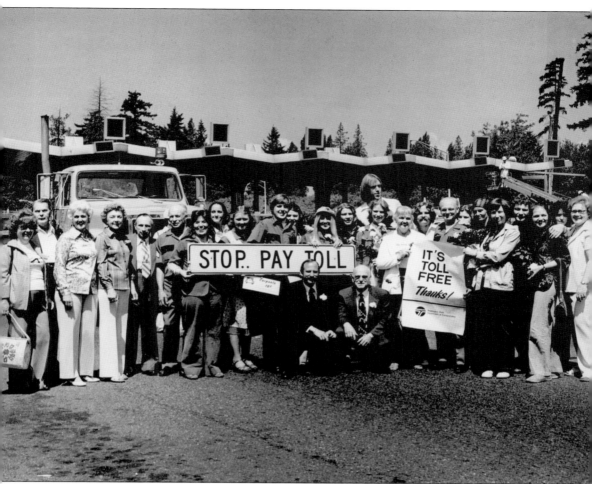

No More Tolls! On June 2, 1979, the state collected its last toll on State Route 520. Traffic grew so fast on the new bridge that the toll was removed years early. Although some argued that the state should have kept tolls in place to fund maintenance, state law only allowed the tolls to pay off construction bonds. Tolls will reappear on the bridge in 2011 as a way to collect revenue needed to build the replacement bridge. (Courtesy of the WSDOT collection, Washington State Archives.)

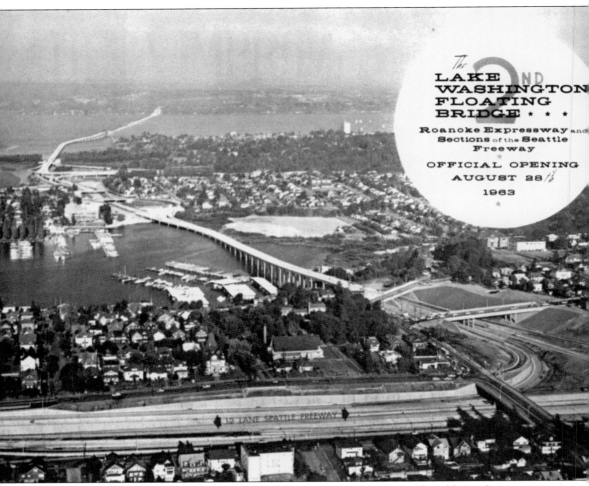

The
LAKE 2ND
WASHINGTON
FLOATING
BRIDGE · · ·

Roanoke Expressway and
Sections of the Seattle
Freeway

OFFICIAL OPENING
AUGUST 28th
1963

12 LANE SEATTLE FREEWAY

ALL ABOUT SEATTLE? The program cover and the opening ceremony itself would give the impression that the new bridge was all about the Seattle end. For most of its life, however, the State Route 520 corridor has had a far greater impact on the Eastside, spurring growth throughout the Points, Bellevue, Kirkland, Redmond, and Sammamish. In the past two decades, with the growth of Microsoft and other large Eastside employers, the bridge has played a larger role in the commute for Seattle residents. (Courtesy of the WSDOT collection, Washington State Archives.)

Five

AT SCHOOL

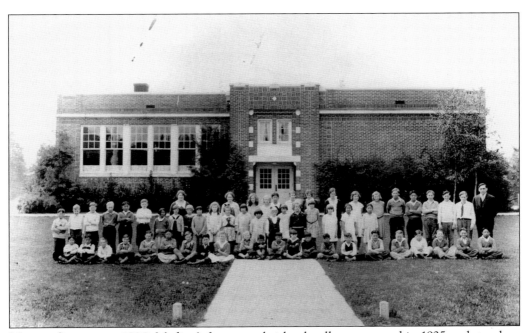

MEDINA SCHOOL, C. 1930. Medina's four-room brick schoolhouse opened in 1925 and stood on the site of the current school parking lot. It was the second of four buildings that would carry the name, the most recent opening in 2006. (Courtesy of the Eastside Heritage Center.)

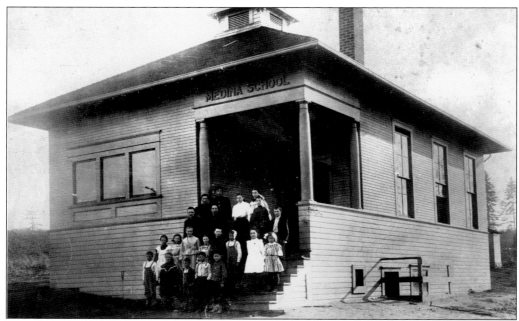

EARLY MEDINA SCHOOL. This undated photograph shows the early one-room Medina school, built in 1910 by the newly formed Medina School District No. 171. In that year, the school census shows 36 children of school age in the Medina district and a corresponding drop in the number of school-age children in the neighboring Bellevue School District No. 49. (Courtesy of the City of Medina.)

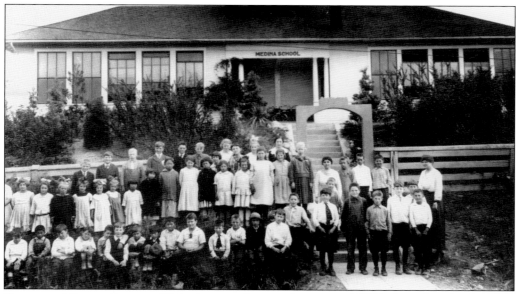

EXPANDED MEDINA SCHOOL. This photograph was taken around 1920 when the school census shows about 75 school-aged children in the district. The district had added new rooms to the earlier building above, located on the southeast corner of what is now Eighty-fourth Avenue and Northeast Tenth Street. This building was destroyed by fire about the time of the completion of the new school. (Courtesy of the City of Medina.)

SCHOOL ON THE HILL. This section of the panorama seen in Chapter 1 shows the Medina School building on Eighty-fourth Avenue in its expanded form, sometime between 1913 and 1917. The Union Congregational Church can be seen to the left of the shed on the left side of the photograph. (Courtesy of the Washington State Archives.)

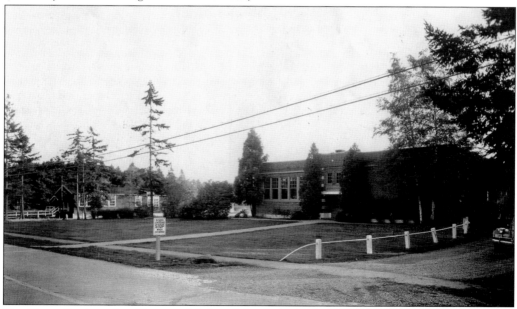

THE BRICK SCHOOL. In addition to Medina School, this picture from the 1930s shows the Medina Community Hall, to the left, about where the current pumping station is located. In 1927, an auditorium from the original school on Eighty-fourth Avenue was moved down the hill to a site adjacent to the new school. The center was used for a variety of activities, many related to school functions. (Courtesy of the Eastside Heritage Center.)

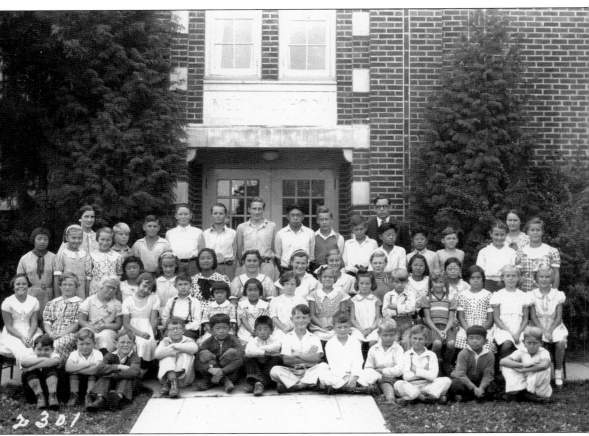

1935 All-School Portrait. The entire student body at Medina School gathers in front of the brick schoolhouse. Although some of the students appear high school age, older children attended high school outside of the district. Because the Medina district did not have a high school, it sent funds to the state that were used to pay for high school education in the district of the student's choice. Several small districts in Bellevue had banded together to create the Union S High School and some Medina students went there. Others, however, chose to take the ferry to Garfield High School in Seattle, taking advantage of the more elaborate facilities and programs. An editorial in the *Reflector* decried this leakage of talent to Seattle, urging Medina residents to support an Eastside high school. (Courtesy of Elizabeth Park Luis.)

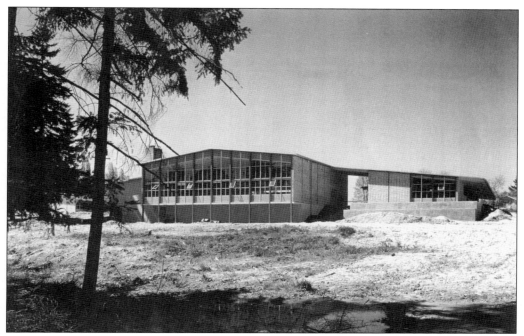

MEDINA ELEMENTARY SCHOOL. In 1957, Medina got its third major school building. In 1942, the Medina district, along with the Hunts Point, Bellevue, Highland, Phantom Lake, and Factoria districts, had consolidated into the new Bellevue District 405, which was dealing with the population explosion taking place throughout the Eastside. The district needed new schools and fast. As with most suburban districts, Bellevue embraced the prevailing aesthetics of the mid-century modern architectural style, as well as popular theories about the relationship of the school environment to learning. The result was a dramatically different campus with all classrooms opening to the outside, linked by breezeways instead of hallways. The entire school was built on one level, with play areas dispersed throughout the campus. The design concepts and inexpensive construction proved insufficiently durable and the building was replaced in 2006. (Both courtesy of the Eastside Heritage Center.)

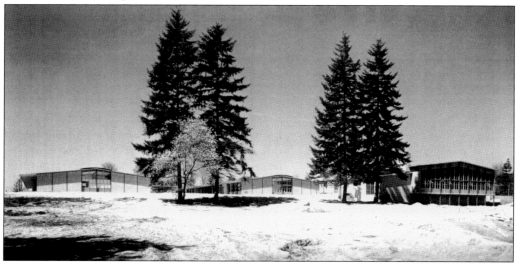

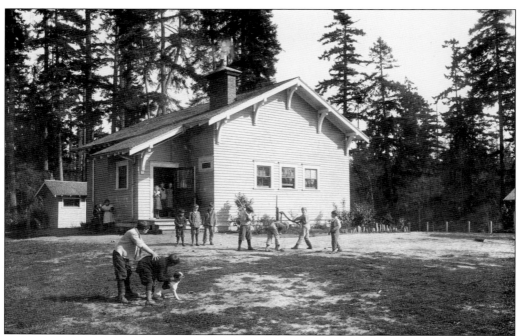

BAY SCHOOL. The Medina School District extended up Clyde Hill to Ninety-second Street but stopped in the north at Twenty-fourth Street. Children living north of Twenty-fourth Street and on Evergreen Point, as well as those in Hunts and Yarrow Points and the north part of Clyde Hill, attended Bay School, located on the site of the current Hunts Point City Hall. Bay School was part of the Hunts Point-Houghton school district No. 22 which extended into south Kirkland. The photograph above shows Bay School in its original 1909 one-room configuration. The building was expanded several times over the years and by 1947, as seen below, it had six classrooms. Bay School burned to the ground in 1950 and was not rebuilt. (Both courtesy of the Eastside Heritage Center.)

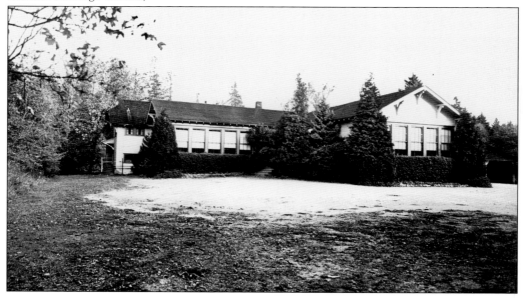

BAY SCHOOL SECOND AND THIRD GRADE, 1936. In the back row, left side, is John Spellman, who grew up on Hunts Point and later went on to become a King County commissioner, King County executive, and governor of Washington (Courtesy of Elizabeth Park Luis.)

BAY SCHOOL, 1941. By this year, Bay School and Medina School were consolidating classes, and a number of older children in this photograph had come from the southern part of Medina, having gone to Medina School for lower grades. Most students at Bay School went on to attend Kirkland High School. (Courtesy of Elizabeth Park Luis.)

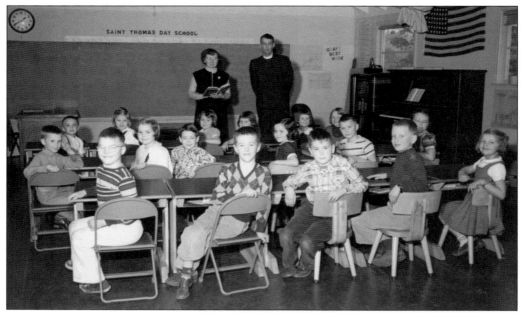

ST. THOMAS DAY SCHOOL. In 1951, with the parish less than 10 years old, St. Thomas Day School opened its doors, welcoming 17 students in first and second grades. The school held classes in Barnes Hall, a parish center built just south of the original church on Eighty-fourth Avenue. The photograph above shows the first class in 1951 with Fr. Arthur Vall-Spinosa. The photograph below shows the first kindergarten class in 1953. The teacher, Genevieve McCracken, taught a morning kindergarten class on Mercer Island and then traveled to Medina to teach afternoon Kindergarten at St. Thomas. (Both courtesy of St. Thomas School.)

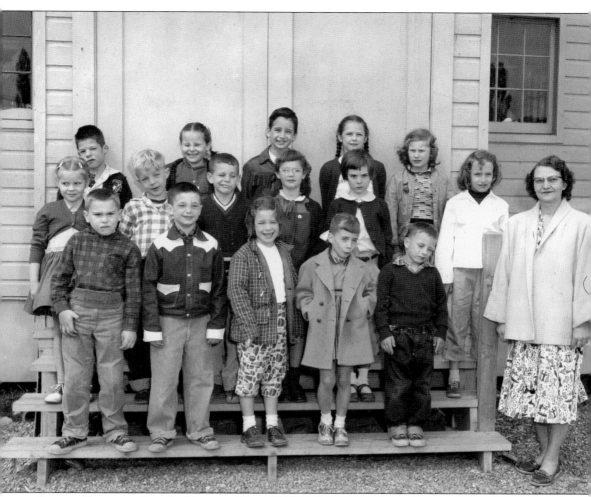

SECOND GRADE AT OLD ST. THOMAS. The 1954 St. Thomas Day School second-grade class poses outside Barnes Hall. Classes continued to be held in Barnes Hall until 1959 when the parish opened its new school building adjacent to the church on Twelfth Street. Not wanting a perfectly good building to go to waste, the school moved Barnes Hall across the street and continued using it as a preschool. In 2008, the school opened a new campus, doubling its capacity. (Courtesy of St. Thomas School.)

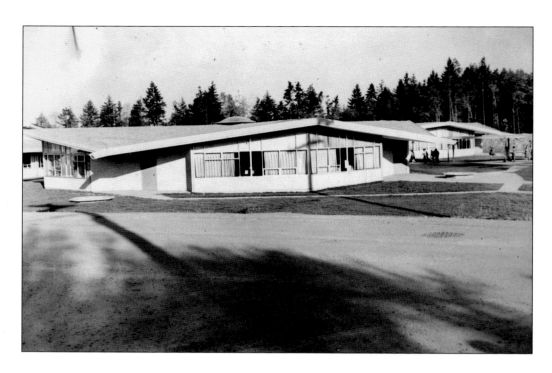

THREE POINTS ELEMENTARY SCHOOL. The Bellevue School District did not rebuild Bay School after it burned in large part because the property was thought to be in the way of the anticipated Evergreen Point Bridge corridor. But with the coming of the bridge, the local population would grow, requiring new schools. The district built Three Points Elementary School on a forested parcel immediately adjacent to the new freeway corridor, opening it in 1961. Three Points was designed by Naramore, Bain, Brady, and Johansen (now NBBJ), the same firm that designed the new Medina Elementary School. Like its counterpart, Three Points was designed with an open campus and an emphasis on being outdoors as much as possible. (Both courtesy of the Washington State Archives.)

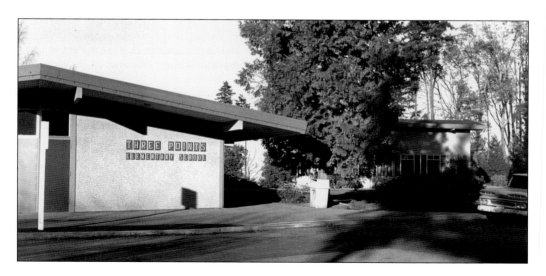

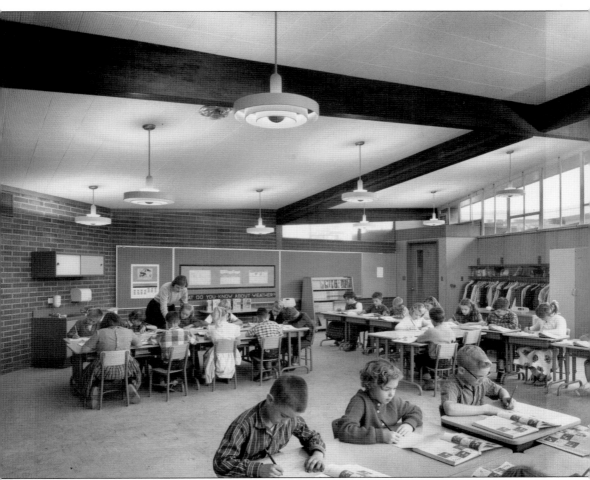

SCHOOLS AND DEMOGRAPHICS. Three Points Elementary School was one of six new schools opened by the Bellevue School District for the 1961 school year because suburban growth and the baby boom had caught up with the school system. Then all that changed. The children in this picture grew up and went to Chinook Junior High School, then Bellevue High School and beyond, but their parents stayed behind with empty bedrooms and, ultimately, empty classrooms. As a result, the Bellevue School District began closing schools in the 1970s and 1980s, including Three Points Elementary, which closed in 1981. In the 1960s, six elementary schools served the area west of Interstate 405, and that was reduced to three. Now even with a resurgent population of children, the district has chosen to enlarge existing buildings rather than reopen old ones. The district still owns the Three Points building and leases it to Bellevue Christian School for its elementary school campus. (Courtesy of the Washington State Archives.)

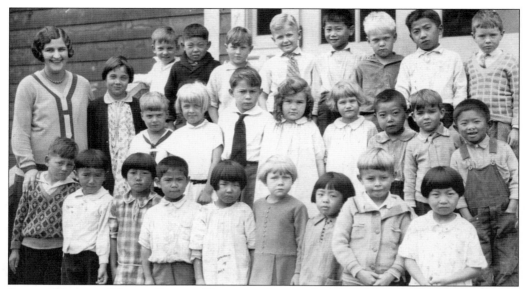

SECOND GRADE AT MEDINA SCHOOL. These two photographs of second-graders at Medina School, taken 18 years apart, in 1928 and 1946 respectively, vividly show the impact of the Japanese-American Internment during World War II. In the 1928 photograph, 11 out of the 26 children are of Asian—mostly Japanese—descent. In the 1946 photograph, there is not a single Asian-American among the children. A large share of the farmers of Medina, and especially the slopes of Clyde Hill, were of Japanese descent and were sent to internment camps at the dawn of the war. Few were able to return to their previous life. (Above, courtesy of the Washington State Archives; below, courtesy of Joan Anderson Shaver.)

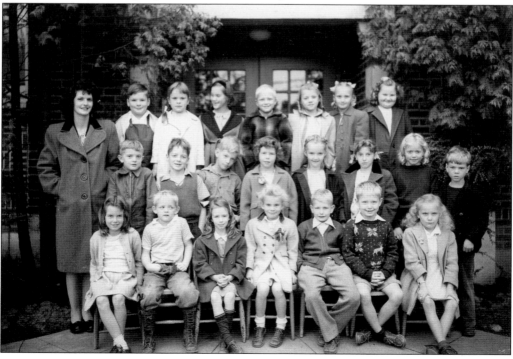

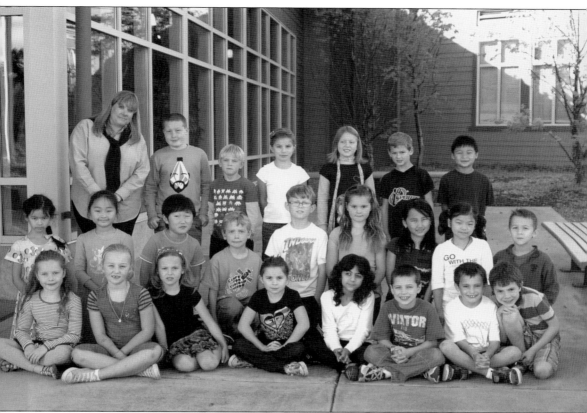

Second grade in 2011. Today young families come to Medina from all over the world, just as they did 100 years ago. The technology boom on the Eastside brings talented people from every continent and many have settled in the area served by Medina Elementary School. Susan Muller's second-grade class poses in front of the latest building, completed in 2006. Unlike the earlier buildings that could accommodate a few dozen children, Medina Elementary School presently has more than 500 students in kindergarten through fifth grade. (Photograph by Leslie Bigos.)

DEMOLITION. From the time of the opening of the new Medina Elementary School in 1957, the original brick building was used sporadically and eventually boarded up and used only for storage. An attempt was made to nominate the structure for historic status, but those efforts failed to save the building, and it was demolished in 1990. (Courtesy of the Washington State Archives.)

Six

HOMES OF MEDINA

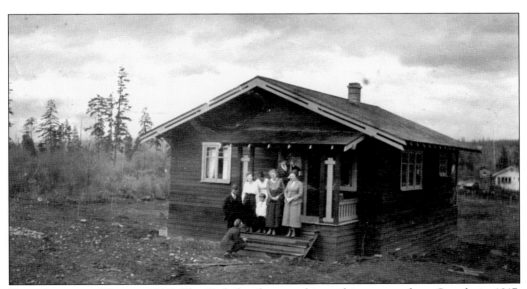

PARK-REYNOLDS HOUSE, 1917. The Park family moved into this cottage from Seattle in 1917. The area had been logged and cleared 25 years earlier, and the Herron's Addition plat had been recorded about five years prior. None of the homes in this area had enough land for more than a family garden and fruit trees, showing that even in this relatively remote area homes were intended for commuters. (Courtesy of Elizabeth Park Luis.)

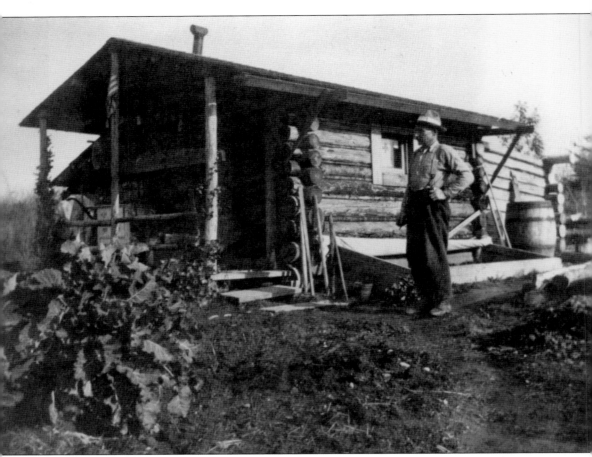

Sourdough Bill's Cabin. Sourdough Bill Lebrick's cabin, built near the corner of Evergreen Point Road and Northeast Twenty-eighth Street, is thought to be the first permanent house built in Medina. Little is known about Lebrick, but the nickname suggests he spent time in mining country. John Frost indicated that his father and Lebrick were friends. (Courtesy of the Eastside Heritage Center.)

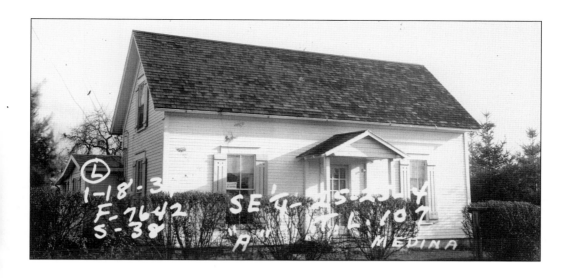

EARLY HOMES NEAR DABNEY'S LANDING. These two homes, which still stand facing each other across Evergreen Point Road just north of the post office, were built in 1900 and are among the earliest frame houses in the area. Roads would have been rudimentary at that time, but steamer service was well established on the lake, and the Old Medina Dock at Dabney's Landing was just south of these houses at the foot of Medina Road. These houses do, however, predate the Medina Grocery, and access to Bellevue—which did not have much to offer either—was limited. The first residents of these homes likely filled most of their supply needs in Seattle. (Both courtesy of the Washington State Archives.)

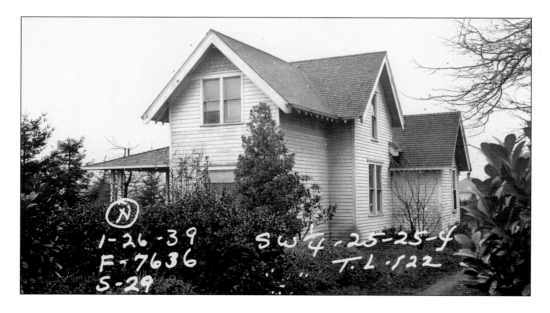

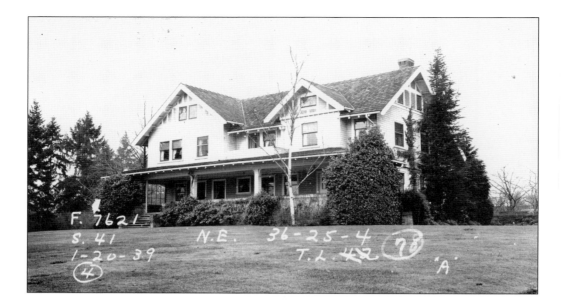

THE EDWARD WEBSTER HOMES. These two houses were built by Edward Webster in 1908 and are perhaps the first of the "executive estate" homes built on the Medina waterfront. Webster was general manager of the Seattle Independent Telephone Company. He built "the Gables," shown above, for his daughter and then built the craftsman-style bungalow below for himself. Webster controlled a large parcel of land and built the houses up from the water, not anticipating that with the lowering of Lake Washington in 1917 they would be even farther from the beach. Both houses remain standing and have been extensively restored, although neither has its original waterfront. (Above, courtesy of the Washington State Archives; below, courtesy of Mark Anderson.)

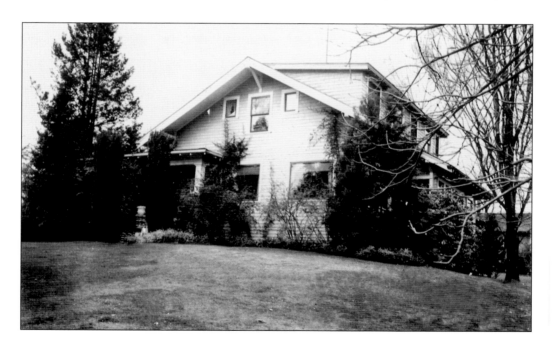

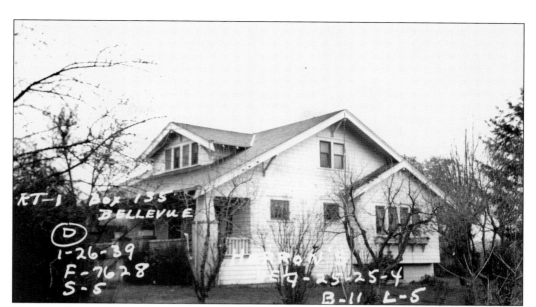

SWANSON HOUSE. Elmer Swason, Phillip Swason, and their sister, Elsa Swanson, emigrated from Sweden and settled in Medina on Seventy-eighth Avenue just north of Twenty-second Street. Elmer was a woodworker and built cabinetry for homes across the Eastside. The family also harvested hay from local fields. (Both courtesy of the Washington State Archives.)

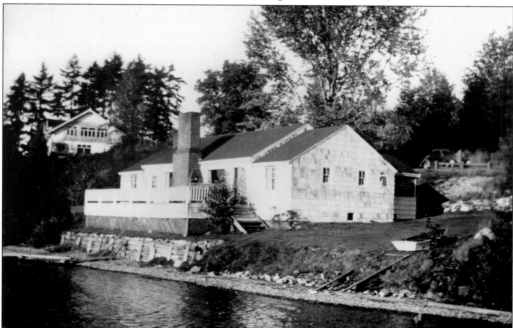

HOUSE NEAR EASTLAND DOCK. This home sat on the water near the Eastland Dock at the foot of Eighty-fourth Avenue. It was rented for many years by Jane McCurdy Bridges, a longtime Medina Elementary School teacher and principal. Both it and the house in the background, which was once occupied by the Medina Baby Home, are gone and most of the site is taken up by the Charles Simonyi mansion. (Courtesy of the Eastside Heritage Center.)

HOUSE OF HEROES. Earl and Mary Barnes raised four sons in this house on Evergreen Point Road. All four of the Barnes boys went on to distinguished careers. Earl himself had been a fighter pilot in World War I. Richard, William, and Robert Barnes were military pilots, serving in the Korean and Vietnam Wars. A fourth son, Jack, was kept from the military for health reasons and became a state trooper. (Courtesy of the Washington State Archives.)

LEBLOND/LOOMIS HOUSE. This large Dutch Colonial on Evergreen Point Road above Lake Washington has had a distinguished list of owners. Early residents were members of the LeBlond Machine Tool family of Cincinnati, and later members of the Loomis Armored Car family. The Gaudette mansion currently occupies the site. (Courtesy of the Washington State Archives.)

FROST HOUSE. Even longtime Medina residents who remember when John Frost ran the Medina Grocery do not know that he grew up in Medina. His father, Jack, raised his family in this house just up the hill from the current Overlake Golf and Country Club tennis courts. The younger Frost not only stayed in Medina to work, he bought a house just a stone's throw from this one, where he lives today. (Courtesy of the Washington State Archives.)

DONWORTH HOUSE. Carey Donworth, who lived in this house from the early 1950s through the 1960s, served for 20 years as the chair of the King County Metro Council, which built the region's first major sewer system and later took over transit service. Donworth also served on the first Medina City Council. (Courtesy of the Washington State Archives.)

THOMPSON HOUSE. Jack Thompson, a Kirkland dentist, and his wife, Zaida, owned this house on Evergreen Point Road. The Thompsons were known as die-hard Washington Huskies fans as well as fanatical golfers. During her year as ladies captain at Overlake Golf and Country Club, the club newsletter described Zaida Thompson as "Mother Superior with an unforgettable swing." (Courtesy of the King County Archives.)

SHANNON HOUSE. This home, built in the early 1900s, had a commanding view of Lake Washington and Mercer Island from the edge of the bluff in Medina Heights. It was owned for many years by the Herb Shannon family. Shannon was president of the Medina Improvement and Good Roads Club during the incorporation movement and later served on the Medina City Council. (Courtesy of the Washington State Archives.)

BUNGALOW ON JOHN LANG ROAD. Twelfth Street, one of Medina's busiest thoroughfares, came a bit late to the road-building party. In 1918, John Lang, who owned land along the route, petitioned the county for a new road and the other landowners supported the petition and supplied the necessary land. This bungalow on the north side of John Lang Road was one of four built in the 1910s, all of which are standing today. (Courtesy of the Washington State Archives.)

TENTH STREET HOME. This home on Tenth Street, which is still standing, was begun in 1927 and worked on slowly for a year or two, but the Great Depression halted progress. A 1939 assessor's photograph shows the house still without siding; this 1940 photograph shows it finished. (Courtesy of Cheryl Borgford.)

McGreevy/Cleary House. This house on Fourteenth Street served as the local base for an ever-changing household made up of various members of the McGreevy and Cleary clans, originally from Montana but later migrating to and from California. Emmet Cleary had been employed at the Skinner shipyard in Houghton. (Courtesy of the King County Archives.)

Flagg House. The Flagg family was among the most active members of the Medina community. Alvin Flagg, a nurseryman, was leader in the Medina Improvement and Good Roads Club and was the first chairman of Medina Water District No. 23, formed in 1928. Carrie Flagg was equally involved in the Ladies Auxiliary of the Medina Improvement and Good Roads Club. They lived near the Swansons on Seventy-Eighth Avenue and Carrie later moved to Overlake Drive. (Courtesy of the Washington State Archives.)

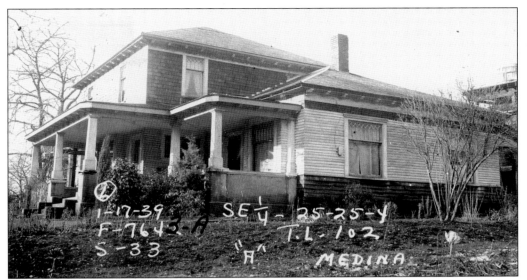

CROFT HOUSE. Early maps show the Croft family owning substantial acreage between Medina Road (sometimes referred to as Croft Road) and what is now Tenth Street. Photographs at the time show the area planted extensively in orchards. Joseph Croft built this house in 1903 and it stayed in the family until the 1960s. It is no longer standing. (Courtesy of the Washington State Archives.)

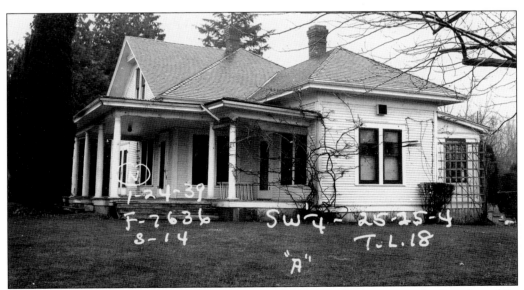

DUTHIE HOUSE. Prominent Medina pioneers, the Duthie family was among the founders of St. Thomas Episcopal Church. Because World War II gas rationing made it difficult for Medina families to take their children to Sunday school at Episcopal churches in Kirkland or Mercer Island, a Sunday school was started in the Duthie family boathouse. The Duthie home was located near where the LaHaye mansion stands today. (Courtesy of the Washington State Archives.)

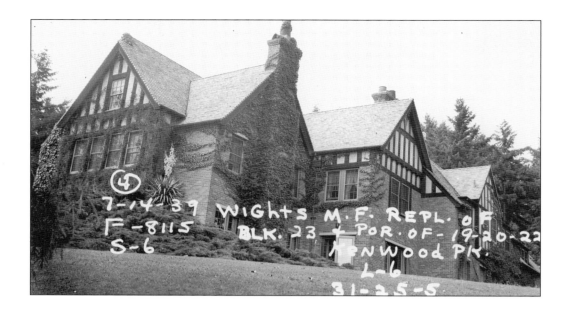

MILLER FREEMAN HOUSE. Groat Point is an unattractive name for what is among the finest home sites in the region. In 1927, Miller Freeman, a successful Seattle publisher (and grandfather of Bellevue developer Kemper Freeman) purchased the property from M. F. Wight, who had controlled much of the Overlake Drive area. Freeman commissioned renowned local architect John Graham to design this 14-room Tudor mansion and the Freeman family moved into the house in 1928. The home was later owned by Sivert Thurston, president of Seattle-based Western International Hotels. During the Thurston era, the home was used as a set for several films. After being sold in the 1970s, the home fell into disrepair and was demolished in 1981 with the property divided into five home sites. (Both courtesy of the Washington State Archives.)

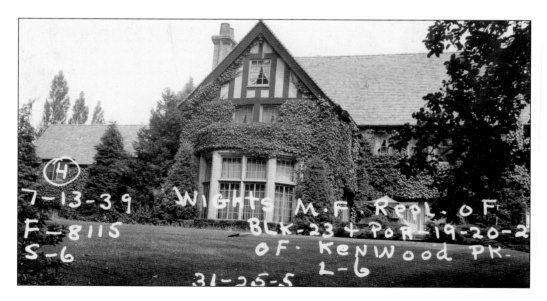

JAMES EDDY HOUSE. Another of the captains of industry to build a home in Medina was James Garfield Eddy. Eddy had made his fortune in the timber industry and was an owner of the Port Blakely lumber mill, at one time the world's largest. Although the house was large and very well situated, the Eddy family continued to live in Everett most of the year, using the Medina house as a summer home. In addition to cutting timber, Eddy was very interested in growing it. He began experimenting with various tree hybrids and started a large experimental forest in California. As such, he landscaped the grounds of his Medina house with interesting varieties. (Both courtesy of John Dillow.)

BILLINGS/HARRIS HOMES ON EVERGREEN POINT. W. J. and Elizabeth Billings purchased the cottage shown above as a summer home in 1924 and by the 1930s were living there full-time. In the days when ferry transportation predominated, the front door of a house was always on the water side and deeds for the properties along the Evergreen Point waterfront specified that all homeowners had to keep open access across their waterfront so neighbors could get to the nearest passenger ferry dock. The Billings house was served by the Rom-No-More dock located three doors to the south. Kathleen Billings, who grew up in the cottage, and her husband, Andrew Harris, built the home below on the property in the early 1960s. It was designed by noted Northwest School architect Ralph Anderson and is still owned by Mrs. Harris Johnson. (Both courtesy of Kathleen B. Harris Johnson.)

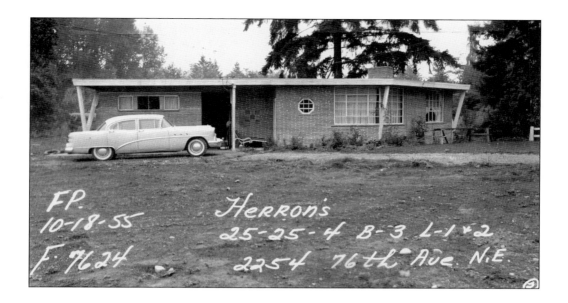

FP.
10-18-55
F. 7624

Herron's
25-25-4 B-3 L-1 & 2
2254 76th Ave. N.E.

Modern Comes to Medina. The postwar suburban housing boom, aided by the opening of the Mercer Island floating bridge, brought rapid growth to the Eastside. In early developments like Lake Hills, Newport Hills, and Eastgate, builders adopted a whole new aesthetic in home design, departing completely from the craftsman and saltbox styles prevalent through the 1930s. The mid-century modern movement came to Medina in two forms. Several quite striking homes designed by renowned architects of the Northwest School appeared on the waterfront. But in the uplands, where land was still inexpensive, entry-level homes like these began to spring up. Medina still had enough undeveloped tracts of land to attract developers and areas such as the north slope south of Medina Heights, and the area between Twenty-fourth Street and Twenty-eighth Street filled in during that time. (Both courtesy of the Washington State Archives.)

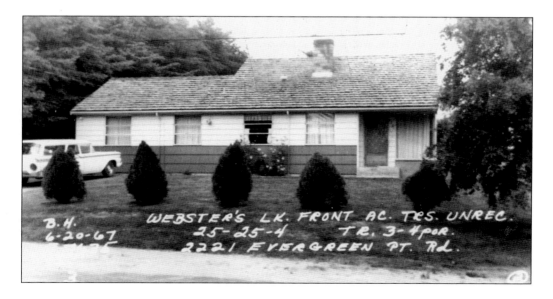

B.H.
6-20-67

WEBSTER'S LK. FRONT AC. TRS. UNREC.
25-25-4 TR. 3-4 POR.
2221 EVERGREEN PT. Rd.

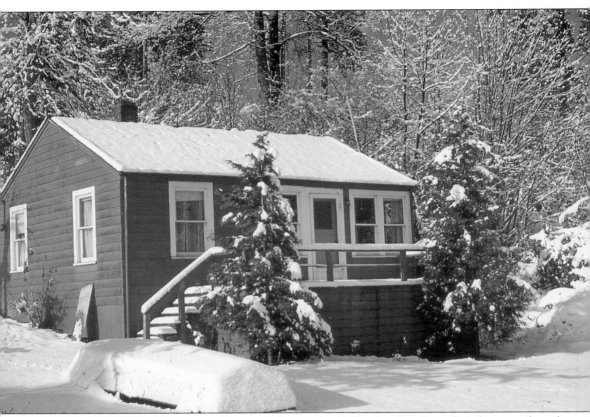

BEACH COTTAGE ON EVERGREEN POINT. As late as the 1960s, the shoreline of Medina was dotted with beach cottages that had been built as summer getaways for Seattle residents. This cottage in Fairweather Bay, shown after a light snow in 1959, was owned by the Lohse family who lived on Evergreen Point Road. (Courtesy of Elizabeth Park Luis.)

Seven

BUILDING A COMMUNITY

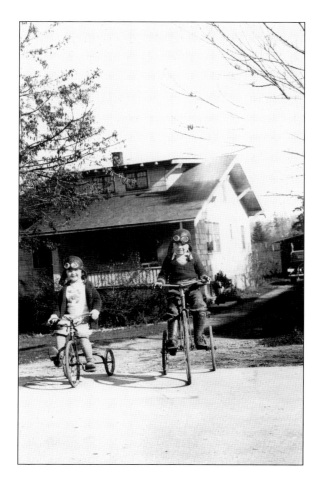

ON THE ROAD. Elizabeth Park and Orville Algyer get set for a tricycle ride on Evergreen Point Road in 1934. Although children can no longer play unimpeded in the street, Medina remains a congenial place to live, and a new generation of families has taken up the mantle of civic leadership. They have inherited a 120-year tradition of grassroots community-building that created roads, schools, water systems, and finally a city government, while at the same time having a lot of fun. A line can be drawn from Medina Improvement and Good Roads Club picnics all the way to today's Medina Days celebration. Although Medina has changed in many ways, the commitment of its residents to building and maintaining a strong sense of community has not. (Courtesy of Elizabeth Park Luis)

MEDINA IMPROVEMENT CLUB

(INC.)

MEETS

FIRST TUESDAY OF EACH MONTH

BOOST MEDINA !!

ATTEND YOUR MEETINGS — PAY YOUR ST LIGHT DUES PROMPTLY

MEDINA IMPROVEMENT AND GOOD ROADS CLUB. The Medina Improvement and Good Roads Club provided a center for community life from the early 1910s until incorporation in 1955. True to its name, the club concentrated on building and maintaining the rudimentary infrastructure that even a rural community needed. The club maintained streetlights near the ferry and store, although collecting dues was always a problem and lights were often turned off for nonpayment. The "good roads" part of the mission meant pressuring the county to build and improve roads and boardwalks. In 1921, the club purchased a fire apparatus and club members led the way to the formation of a water district in 1928. Like many community activities, the club went through cycles of heavy activity and near-death but lived on to provide leadership for the incorporation movement of the 1950s. (Courtesy of Elizabeth Park Luis.)

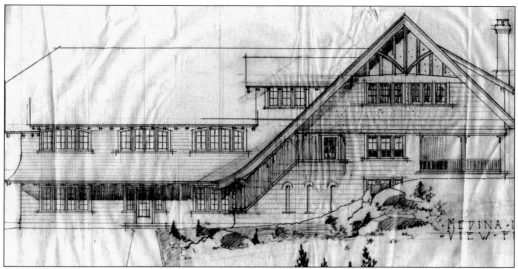

THE QUEST FOR A CLUBHOUSE. In 1923, the Medina Improvement and Good Roads Club secured a title from the county to a strip of land just north of the ferry terminal. The club then set about commissioning designs for an elaborate clubhouse, two of which are shown here. The club was never able to get the project off the ground but held onto the property year after year, rebuffing a 1935 attempt to return the property to the Johnstons, who had originally ceded it to the county for the ferry terminal. When the Mercer Island Bridge opened in 1940 and ferry service ended, the club leased the terminal building, which had long served as a social center, and finally had a clubhouse. The club's strip of property now forms the north section of Medina Beach Park. (Both courtesy of Elizabeth Park Luis.)

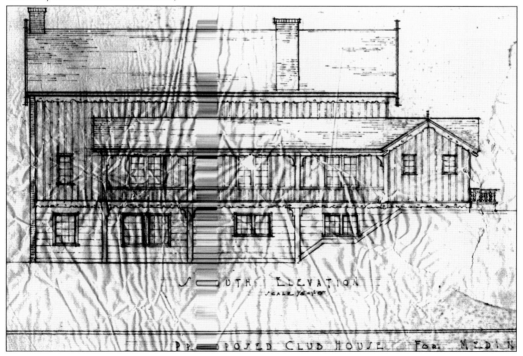

STATE OF WASHINGTON | DEPARTMENT OF STATE

I, **A. LUDLOW KRAMER**, Secretary of State of the State of Washington and custodian of its seal, hereby certify that according to the records on file in my office

A special election was held on July 26, 1955 at which time the electors of King County residing in the community of

𝕸𝖊𝖉𝖎𝖓𝖆

determined that such community shall become a city of the third class under the council-manager form of government.

I further certify that the original councilmen elected were: William E. Park, Frederic E. Templeton, Mary Barbee, C. Fred Dally, Robert J. Behnke, C. Carey Donworth and W. P. Hagen and that a certified copy of the official election returns were filed with the Secretary of State as of August 19, 1955.

In witness whereof I have signed and have affixed the seal of the State of Washington to this certificate at Olympia, the State Capitol,

MARCH 3, 1971

| DEPUTY SECRETARY OF STATE for | A. LUDLOW KRAMER SECRETARY OF STATE |

INCORPORATION! The path to incorporation was not a smooth one. With the 1953 incorporation of Bellevue, which the Points communities declined to join, it was clear that city government was in the future. Just what form that might take, however, remained in dispute. One faction favored annexation to Bellevue and circulated petitions in early 1955. At the same time, the Medina Improvement and Good Roads Club pushed for incorporation and circulated its own petitions. Although both factions rounded up enough signatures, the incorporation faction was able to get on the ballot faster since the annexation process required approval by the City of Bellevue, which took longer. In a special election on July 26, 1955, voters of the Medina and Evergreen Point communities voted in favor of incorporation and the city was born. (Courtesy of the City of Medina.)

PROFESSIONAL CITY GOVERNMENT. Medina adopted the council-manager form of government in which a volunteer city council hires a professional to run the government. In the back row of this 1967 photograph, city manager Robert Pearson is third from the right. Longtime police chief Al Anglin is third from the left and Mayor Thornton Thomas is second from the right. (Courtesy of the Washington State Archives.)

MEDINA POLICE DEPARTMENT. Like many small cities that incorporated in the 1950s, Medina chose to contract for fire and utility service but did opt to form its own police department. As shown in this photograph, the Medina Police Department had a harbor patrol for many years before turning that function over to King County. (Courtesy of the City of Medina.)

WALTER HAGGENSTEIN. In 1908, when he was a young man, Walter Haggenstein helped his father run the Medina Grocery. He moved to California in 1918 but regained control of the store in 1924. He later sold the store but stayed on as postmaster. He is shown here on his 70th birthday in 1954. In addition to being a grocer and postmaster, he was also a renowned ornithologist with an extensive knowledge of regional birds. Driving in his decrepit truck, he was known for unexpectedly heading into the underbrush, having sighted a rare bird. After retiring, Haggenstein lived in what had been the telephone exchange and is now the Medina Post Office. (Courtesy of the Eastside Heritage Center.)

NORTON CLAPP. Perhaps no Medina resident, before or since, has had as big an impact on the landscape of Medina as Norton Clapp. This photograph shows him in his natural habitat, a civic committee—in this case the board of the Overlake Golf and Country Club (back row, second from left). The Clapp family was associated with the Weyerhaeuser Company and Norton's older brother, James, had been a Medina resident from the 1920s, starting the original Overlake Golf and Country Club and later raising horses on the defunct golf course. Norton moved to Medina in 1946, buying the former home of Clarence Blethen of the Seattle *Times*. He reacquired the golf-course-turned-ranch, gave a corner to St. Thomas Episcopal Church, and helped restart the club. He then developed home sites on the northwest part of the course. His Medina property is now home to Jeff Bezos of Amazon. (Courtesy of Overlake Golf and Country Club.)

HAROLD ANDERSON. In 1935, Harold Anderson moved his family from Seattle to Medina, much to the bewilderment of his law partners. But he had discovered the joys of quiet suburban living and commuted first by ferry, then by bridge, to Seattle. He is shown here with his daughter Joan at their home on Rambling Lane. (Courtesy of Joan Anderson Shaver.)

RADFORD FAMILY. Jean and Fenton Radford are shown here with their children Linda (left), Ann (center), and Foster (standing) at the Evergreen Point home they had barged in from Enetai in 1940. Jean Foster Radford's father had purchased most of the end of Evergreen Point in 1921, giving his daughter a home site on the west side. (Courtesy of Colin Radford.)

YABUKI FAMILY. In the 1930s, the Yabuki family acquired the Hunts Point greenhouse operation from the founders, the Boddy family. Although, like all the Japanese-American families of the Eastside, the Yabukis were sent to internment camps during World War II, they returned after the war and resumed operations at the greenhouses. The family also farmed the lowlands at the head of Fairweather Bay, where State Route 520 now cuts through. The Yabuki property was sold in the 1970s and developed into what is now Medina Circle. (Courtesy of the Eastside Heritage Center.)

Membership Roll

Mrs. H. F. Bergis
Mrs. E. B. Drisko
Mrs. A. B. Flagg
Mrs. F. T. French
Mrs. F. E. Gorham
Mrs. A. E. Green
Mrs. F. E. Horton
Mrs. W. M. Johnson
Mrs. J. Lang
Mrs. J. B. Lincoln
Mrs. C. T. Lyons
Mrs. W. E. Meyers
Mrs. Eva Miller
Mrs. C. Newlands
Mrs. H. C. Ostrom
Mrs. L. V. Palmer
Mrs. W. E. Park
Mrs. S. C. Sawtelle
Mrs. R. J. Steinhaus
Mrs. E. A. Thompson
Mrs. R. K. Watt
Mrs. J. C. Weber
Miss S. S. Williams

Medina

Woman's Club

1924~1925

Medina, Washington

"Nothing lovelier can be found in woman
than to study household good" —Milton

MEDINA WOMEN'S CLUB. In 1924, Medina may have looked a little rough, but the women of the community did their best to promote gentility. The Medina Women's club—which is distinct from the Ladies Auxiliary of the Medina Improvement and Good Roads Club—existed simply for the betterment of its members. Hosting duties rotated, as did responsibility for entertaining and educational presentations. (Both courtesy of Elizabeth Park Luis.)

Program

September Eleventh
Hostess Mrs. Lincoln
Luncheon
Regular Business Meeting
Roll Call Vacation Reminiscences
Washington State Counties

September Twenty-fifth
Hostesses
Mrs. Watt, Mrs. Flagg, Mrs. Park
Luncheon
Presidential Candidates Mrs. Johnson
Life of Mrs. Ferguson Mrs. Watt

October Ninth
Hostess Mrs. Ostrom
Regular Business Meeting
Violin solo Maxime Lembke
Piano Accompaniment Mrs. Ostrom
Discussion of Proposed Amendments

October Twenty-Third
Hostesses
Mrs. Gorham, Mrs. Bergis, Mrs. Johnson
Luncheon
Herbacia borders and shrubs
Mrs. Bergis

Edible Mushroons Mrs. Watt

November Thirteenth
Hostess Mrs. Ostrom
Regular Business Meeting
Reading of Initiatives Mrs. Bergis
Hawaiian Missionaries Mrs. Thompson
Facts About Alaska Mrs. Steinmetz
Piano solo Miss Jean Ostrom

November Twentieth
Hostesses
Mrs. Thompson, Mrs. Horton Mrs. Weber
Luncheon
Roll Call Helpful Hints
Shrubs Mrs. Flagg
Calories and Health Mrs. Park

December Eleventh
Hostess Mrs. Flagg
Regular Business Meeting
Christmas Reading Mrs. Weber
Travelogue, "Christmas Across the Water"
Mrs. Schoenfeld
Violin Solo Walter Lembke
Accompaniment by Miss Eleanor Ostrom

January Eighth
Hostess Mrs. Miller
Regular Business Meeting
Roll Call New Year's Resolutions

IMPROVEMENT AND GOOD ROADS CLUB PARTY. The Ladies Auxiliary of the Medina Improvement and Good Roads Club held frequent parties, open to all residents of the area. These often had themes and served as fund-raisers for a variety of causes. In the early days, the ladies auxiliary turned the proceeds over to the club itself, which was chronically broke. Later the proceeds from events were given to the Mothers Club of Medina School. Parties were frequently held at the Medina School auditorium, although this photograph appears to have been taken at the ferry terminal building. (Courtesy of Elizabeth Park Luis.)

GYPSIES! This party brought out the "gypsy" in the Medina Improvement and Good Roads Club. (Courtesy of Elizabeth Park Luis.)

PARTY TIME. Pictured at a birthday party on Evergreen Point Road in 1940, are, from left to right, Sylvia Smith, Harriet Tremper, JoAnne Hughes, Grace Tate, Toddy Haynes, Aroha Shannon, Barbara Fotheringham, Nancy Wesley, Kathleen Billings, Jo Kanizeski, Celia Herman, Mary Tate, Jeanette Thompson, and Elizabeth Park. (Courtesy of Elizabeth Park Luis.)

TOTEM POLE. The Anderson children at home on Rambling Lane, are, from top to bottom, Joan, James, and Thomas. (Courtesy of Joan Anderson Shaver.)

GROWING UP IN MEDINA. Those who have grown up in Medina often talk about the easy mixing of children from different income levels. Above, the grandchildren of James Garfield Eddy get a ride in a fancy carriage. At about the same time, just up the street, two boys of some lesser means play roller hockey with homemade sticks in the middle of Evergreen Point Road. (Above, courtesy of John Dillow; below, courtesy of Elizabeth Park Luis.)

SCOUTING IN MEDINA. The Medina schools, as well as St. Thomas Episcopal Church, have long supported scouting. Shown above is the charter for a troop at Medina School from 1929. But scouting goes back farther than that, with the Ladies Auxiliary of the Medina Improvement and Good Roads Club recruiting Boy Scouts to help keep the on-dock waiting shed at the ferry terminal clean in 1917. Medina has also been home to two national chairmen of Boy Scouts of America: Norton Clapp and Charles Piggott. (Courtesy of Elizabeth Park Luis.)

BROWNIES ON A NATURE HIKE, 1947. A Brownie troop from the Medina-Hunts Point area, guided by Mrs. Baird and Mrs. Henry, goes on an outing in what is now the Wetherill Nature Preserve. (Courtesy of Joan Anderson Shaver.)

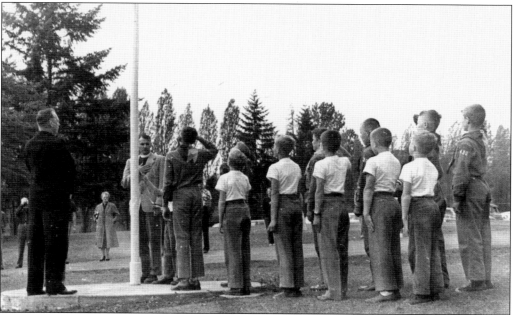

BOY SCOUTS. Boy Scouts from Medina conduct a flag salute at the opening of the Overlake Golf and Country Club in 1953. Fr. Gerald Moore of Sacred Heart Catholic Church on Clyde Hill stands to the left, and Rev. Arthur Vall-Spinosa, of St. Thomas Episcopal Church, stands behind the flagpole. (Courtesy of Overlake Golf and Country Club.)

ABOARD THE *LESCHI*. Although Medina felt rural in its early days, the big city was just minutes away by ferry. Here a group of Medina residents rides the *Leschi*, dressed for an excursion to Seattle. The Yesler Street cable car met the ferry at the Leschi dock and whisked passengers downtown in minutes. (Courtesy of Elizabeth Park Luis.)

EXCURSIONS TO MEDINA. The unidentified people in this photograph, taken in front of the ferry terminal, likely took an excursion to visit Medina for the day. Pleasure cruising on the lake was the earliest use of steamers, and trips to the Eastside continued to be a popular activity. The Medina Improvement and Good Roads Club even installed benches near the ferry dock for picnickers. The concessions in the ferry terminal prospered through the patronage of those crossing from Seattle. (Courtesy of the City of Medina.)

FREQUENT VISITOR TO SEATTLE. John Woodson served as a butler for the Fisher family, prominent early Medina residents. He was a frequent visitor to Seattle, with his top hat, gloves, and cane, and is said to be the person who convinced the Hagensteins to sell their grocery on Yesler Way in Seattle and to buy the Medina Grocery. He is shown outside the Medina Grocery in this undated photograph. (Courtesy of the City of Medina.)

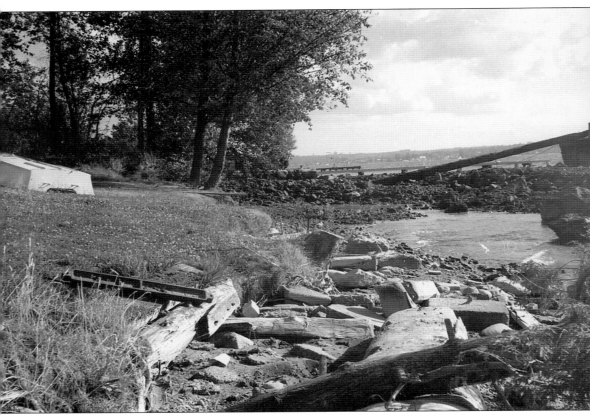

CREATING MEDINA BEACH PARK. The area in front of the ferry terminal had always been open to visitors, and after ferry service stopped the entire beach was open to swimming. After incorporation, when the new city took the property over from the county and the Medina Improvement and Good Roads Club added its piece of land to the north, the city set out to build a beach park. As seen in this photograph, the rock bulkhead was first constructed in front of city hall, and then the space behind was filled with dredged sand. Earlier photographs of the ferry terminal show the water coming very near the building, but thanks to this filling, the beach property now stretches well out. (Courtesy of the Washington State Archives.)

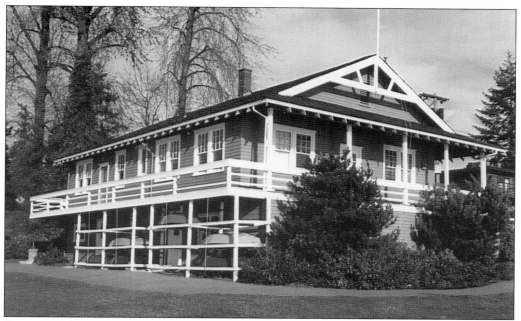

RECREATION PROGRAMS. From the 1960s until the 1980s, the City of Medina sponsored an extensive recreation program. The photograph above shows the fleet of El Toro sailboats (on racks under the city hall deck) used for sailing lessons at the beach, which began in 1969. Tennis lessons were offered at the Fairweather Park tennis courts, shown below. Lifeguards gave swimming lessons at the beach and some years the city hired playground supervisors at Medina and Three Points schools to organize field games. (Above, courtesy of the City of Medina; below, courtesy of the Washington State Archives.)

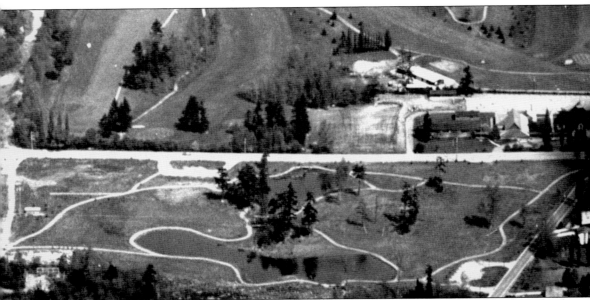

MEDINA PARK. In the early 1960s, the city acquired a large tract of undeveloped land south of the Overlake Golf and Country Club golf course that had been platted but never developed. The stream that drains the golf course ran through the property and it was mostly thought of as an impenetrable swamp. The city held a naming contest for the park with the winner announced at Medina Days, and a young Medina resident impressed the judges with "Pollywog Park." Somehow the name did not stick. This aerial photograph shows the park shortly after construction, with the two ponds and trail network that define the park landscape today. (Courtesy of Overlake Golf and Country Club.)

5TH ANNUAL MEDINA DAY SEPTEMBER 6TH

This year we are celebrating our 5th annual festival honoring all citizens of Medina. It is the one day each year we have set aside to renew the community spirit which prevailed in earlier years. We plan again in this year to provide a full day of events and have tried to schedule them so people may participate in as many as possible. Since we try to keep this day local in feeling, we ask that <u>all</u> families participate in as many activities as they wish.

Since the incorporation of Medina, residents have come forth at various times and places to do what was necessary to make ours the.. pleasant little city it is today. Medina Day is the City's "thank-you" to all its people, and we do hope you will share in the fun of this day with us.

Our schedule follows. If there are any changes they will be posted in the Medina Store -- with the kind permission of John Frost.

9:00 <u>COSTUME PARADE WITH MARCHING BAND</u> Due to the great demand elsewhere for our resident band (not to mention it's doubtful make-up) we will urge all participants to bring whatever they like to provide music. In the absence of "music", noise will do. So break out the bugles and drums, cymbals and castanets, put on a funny hat and come march. The parade will form at St. Thomas with John and Wendy Vachal directing traffic, will proceed past the school to the store, where ribbons will be awarded.

9:00 <u>BIKE RACE</u> From Fairweather Park to Medina Store. Chief Anglin, with the help of Boy Scouts, will sort all entrants out at the starting post. <u>Please be there by 8:30.</u>

11:00 <u>TENNIS MATCHES</u> To be at Fairweather Park. All ages are invited. Further information <u>might</u> be gained by calling Elizabeth Luis at GL 4 0463.

12:00 <u>SAILBOAT RACES</u> will be held at Medina Beach. Boats 14 feet and under will be eligible. Interested persons are asked to call Mary Ellen Kauffman at GL 4 7169. With all those sailing lessons Craig Thomas has given this summer we expect some real competition.

1:00 <u>FIELD RACES</u> These will be held at Medina School, for ages 4 through 6th grade, under the direction of Kay Anderson. Kay has great ideas for races, so come and see if you can't go home with a ribbon!

3:30 <u>PIE EATING</u> This messy event will take place outside City Hall. PLEASE NOTE: OUTSIDE! Bring your appetite and we'll furnish the napkins.

4:30 <u>CAKE DECORATING</u> Also to be held at City Hall. Please bring your entry with your name and age attached. Ann Templeton and Lassie Wittman will be in charge of this tempting bit of business. All cakes will be returned to you.

5:30 <u>BAND CONCERT AND FAMILY PICNIC</u> At Medina Beach. Bring your family and picnics, but <u>PLEASE</u> not your pooch!

7:00 to
9:00 <u>STREET DANCE</u> For teenagers and all others who feel up to it. Live music for the latest dances. Medina School - chaperones on hand.

Please come and enjoy as many of these events as you can -- and hope it does not rain. See you September 6!

Elizabeth Luis, Chairman

MEDINA DAYS, 1969. This program shows the day's activities for the fifth annual Medina Days in 1969. The annual civic celebration has endured in the same spirit, and with some of the same events. As today, Medina Days was a volunteer undertaking, supported by community contributions. (Courtesy of Elizabeth Park Luis.)

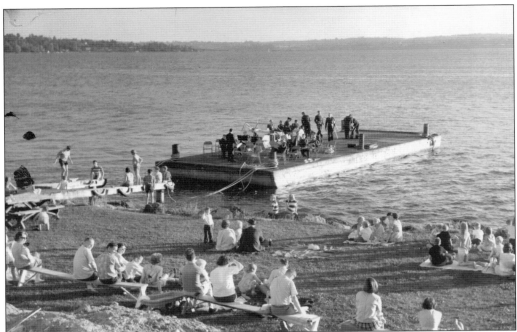

MEDINA DAYS, 1965. In its early days, Medina Days featured a family picnic at the beach and a band concert from a barge anchored just offshore. The U.S. Navy happily sent a brass band from the Sand Point Naval Air Station to play favorite marches. Medina Days grew to include a bicycle race, sailing race, tennis tournament, field games, pie eating contest, and a cake-decorating contest—all in one day. The final event was a dance with a live band held in the Medina Elementary parking lot, complete with noise complaints from neighbors. (Both courtesy of the Washington State Archives.)

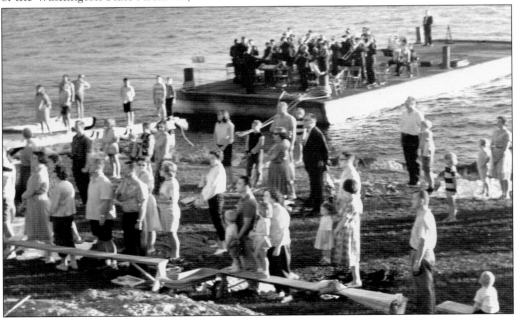

Medina Days 2009. Kids line up at St. Thomas Episcopal Church for the Medina Days parade, in which participants vastly outnumber spectators. This is a good metaphor for a healthy community: few people content to sit on the side and watch. The pioneer spirit of cooperation lives on in a city rich in social capital. Every year, someone needs to step forward and organize the parade—and someone always does. (Photograph by Maryann Luis.)

www.arcadiapublishing.com

Discover books about the town where you grew up, the cities where your friends and families live, the town where your parents met, or even that retirement spot you've been dreaming about. Our Web site provides history lovers with exclusive deals, advanced notification about new titles, e-mail alerts of author events, and much more.

MADE IN THE

Arcadia Publishing, the leading local history publisher in the United States, is committed to making history accessible and meaningful through publishing books that celebrate and preserve the heritage of America's people and places. Consistent with our mission to preserve history on a local level, this book was printed in South Carolina on American-made paper and manufactured entirely in the United States.

This book carries the accredited Forest Stewardship Council (FSC) label and is printed on 100 percent FSC-certified paper. Products carrying the FSC label are independently certified to assure consumers that they come from forests that are managed to meet the social, economic, and ecological needs of present and future generations.

FSC
Mixed Sources
Product group from well-managed
forests and other controlled sources

Cert no. SW-COC-001530
www.fsc.org
© 1996 Forest Stewardship Council

Find Your Place in History.